IMAGES
of America

WASHINGTON
COUNTY

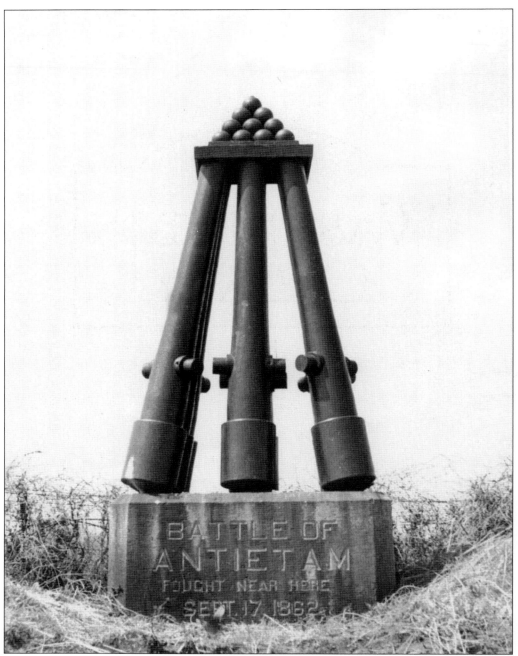

This close up of the cannonball monument at Antietam Railroad Station was taken in 1959 just before the monument was dismantled and donated to the Antietam National Battlefield Park. Made of authentic iron cannonballs on top of real cannon barrels, the monument was built by the Norfolk and Western Railway c.1880 when Antietam Station still had passenger service. The cannon balls were put in storage at the park and the barrels were mounted on reproduction carriages at various locations in the park. (Courtesy Western Maryland Room, Washington County Free Library.)

IMAGES
of America

WASHINGTON
COUNTY

Mary H. Rubin

ARCADIA

Copyright © 2001 by Mary H. Rubin.
ISBN 0-7385-1418-7

Published by Arcadia Publishing,
an imprint of Tempus Publishing, Inc.
2 Cumberland Street
Charleston, SC 29401

Printed in Great Britain.

Library of Congress Catalog Card Number: 2001098141

For all general information contact Arcadia Publishing at:
Telephone 843-853-2070
Fax 843-853-0044
E-Mail sales@arcadiapublishing.com

For customer service and orders:
Toll-Free 1-888-313-2665

Visit us on the internet at http://www.arcadiapublishing.com

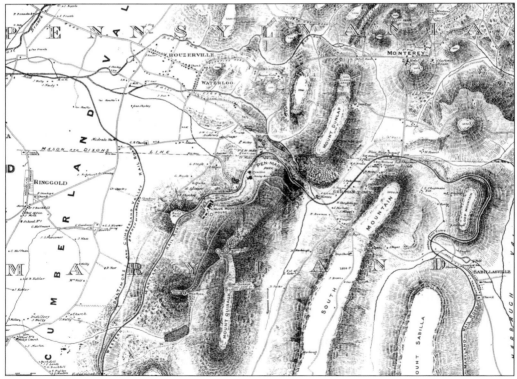

The Pen-Mar region is shown here on a rare map made for the Western Maryland Railroad in 1885. Property owners and towns are marked on the map as well as rail lines, hotels, and other buildings at Pen Mar Park. There is a notation for an "S. Royer" on South Mountain that depicts the spot where Lake Royer would be built in 1901 and around which Fort Ritchie would later be constructed. (Courtesy *Maryland Cracker Barrel*.)

CONTENTS

ACKNOWLEDGMENTS

The author wishes to gratefully acknowledge Frank Woodring for allowing access to the wonderful photos and information found in the *Maryland Cracker Barrel* magazine. I also wish to thank the Washington County Historical Society and the Western Maryland Room of the Washington County Free Library. Both provided generous access to their collections as well as answers to questions. I would also like to thank Kay Rubin for helping gather, sort, and assemble information. Finally, my thanks to everyone in the community who was so enthusiastic in their support of my earlier title, *Hagerstown*, which led to this new volume.

INTRODUCTION

Washington and Antietam Streets in Hagerstown, Potomac and Conococheague Streets in Williamsport, Canal Street in Hancock—the names of the streets alone conjure up images from the history of Washington County. Located in the heart of the Cumberland Valley, between the Blue Ridge and Allegheny Mountains, Washington County has been at the crossroads of history and commerce since its earliest settlement at Conococheague, dating back to 1737. Prior to that time, early settlers had been reluctant to cross the Blue Ridge Mountains into the great-unknown western lands. Native Americans were a constant threat in those early years but the abundant wildlife and fertile soil of the area continued to attract adventuresome settlers.

After the Revolutionary War, Washington County was created by the first Maryland State Convention on September 6, 1776 at the Maryland State House in Annapolis. Originally part of Frederick County, the new county named for Gen. George Washington contained all of the land that makes up present day Washington, Allegany, and Garrett Counties.

As the pioneer movement in the new nation began to take hold, Washington County moved into the forefront as the National Road took its path west from Baltimore straight through the county. For years, the road was the busiest in America, and Washington County was one of the major stopping places along the route. Industries sprang up to meet the growing needs—inns and taverns for weary travelers, tollhouses to collect fees for use of the road, and factories of all manner of goods for settlers to take with them for private use or to be sold at western outposts.

The sheer volume of goods being moved from the east coast to the western frontiers and farmlands brought about the idea for the Chesapeake and Ohio (C&O) Canal. Originally designed to begin at the Chesapeake Bay and end in Ohio, the canal promoted a quicker alternative to the long land route. George Washington had visited the region himself in search of ways to improve navigation along the Potomac River, hoping to link it with the Ohio River. It took Maryland until 1853 to build the canal from Georgetown to Cumberland. The Western Maryland Railroad actually ended up reaching from Baltimore to Cumberland before the canal was completed. Later, the Baltimore and Ohio (B&O) Railroad built a line into Hagerstown with plans to compete with the canal for faster transportation. The railroads did prove to be more efficient and rail traffic in the region grew exponentially.

Situated on the Mason-Dixon line dividing North from South, Washington County played a critical role in the Civil War. Truly on the fence, Maryland had citizens supporting both sides of the cause. Washington County was occupied by military troops for four of the five long years

of the war. In fact, the war's worst day of fighting took place within the county's borders at Sharpsburg in 1862.

Washington County continued to prosper and grow and is still a vibrant region today, having recently celebrated its 225th anniversary. Offering concerts, museums, historical attractions, a wide variety of outdoor opportunities, and much more, Washington County is home to more than 131,000 people. Many have family histories in the region that go back for generations while others are just beginning to put down roots. All of them have the rich heritage of the county in common. In these troubling times for our nation it is such common bonds that pull communities together. We look forward to an even prouder next century for this historic county.

One
SHARPSBURG AND ANTIETAM

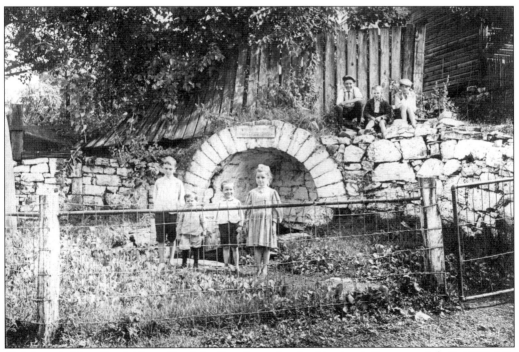

Col. Joseph Chapline laid out "Joe's Lot" at the spring in Absolom's Forest on July 9, 1763. His settlement, known as Sharpsburg, Maryland, was named for Maryland governor Horatio Sharpe who granted the land to him. In this 1907 view we see the town's original water supply—the Great Spring. (Courtesy Washington County Historical Society.)

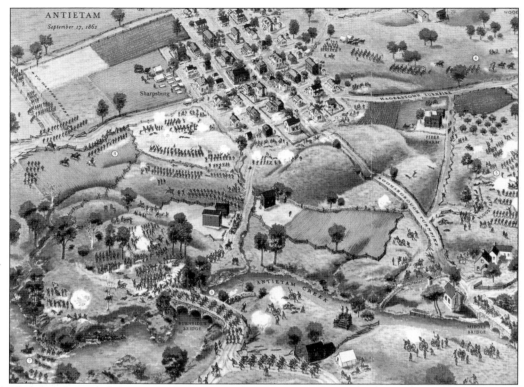

This aerial map of Antietam from September 17, 1862 shows the location of various troops, bridges, roads, and buildings. The town of Sharpsburg is in the upper left and the Hagerstown and Boonesborough Turnpikes can be seen leading out of town. (Courtesy Washington County Historical Society.)

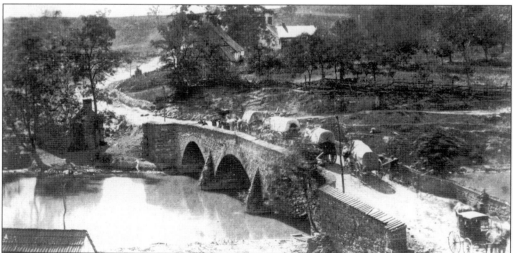

This view from the Porterstown Bridge looks west toward Sharpsburg. The bridge is sometimes listed as the Middle Bridge on Antietam Battlefield maps. There is a partial view of Newcomer's barn on the extreme left of the upper ridge. General Lee's first line of defense on September 15, 1862 was on the ridge behind the barn. (Courtesy Washington County Historical Society.)

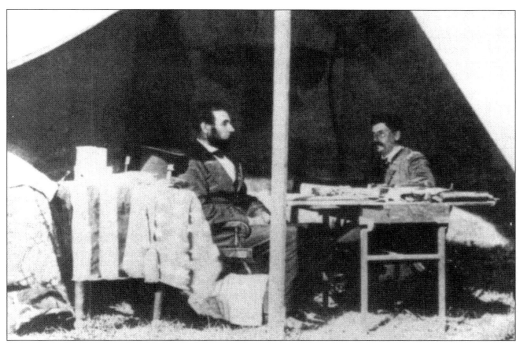

Here, President Abraham Lincoln and Gen. George McClellan confer in a tent near Sharpsburg in October 1862. Lincoln's Emancipation Proclamation was issued just a few short months after this meeting on January 1, 1863. Lincoln himself noted that he reached the decision about when to release the proclamation primarily during his Antietam visit. (Courtesy *Maryland Cracker Barrel*.)

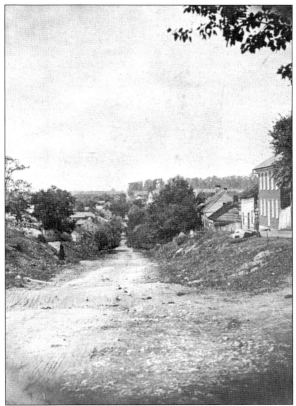

Looking toward Shepherdstown, West Virginia, this is Main Street in Sharpsburg as it appeared in 1867. (Courtesy *Maryland Cracker Barrel*.)

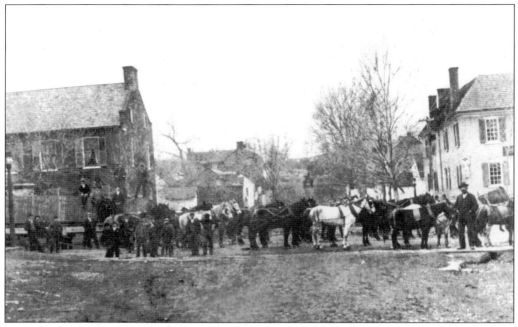

Many horses were used to move the shaft of the Philadelphia monument from the railroad station to its position on Antietam Battlefield. The Philadelphia monument is on the site of the West Woods Ambush and is one of approximately 250 monuments built after the Civil War. President Theodore Roosevelt dedicated the monument upon its installation. (Courtesy Washington County Historical Society.)

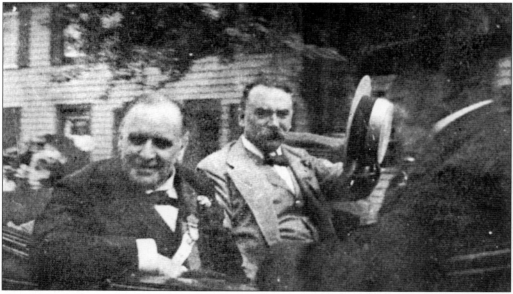

Washington County has been graced with visits from many United States presidents including Abraham Lincoln and Franklin D. Roosevelt. This rare photo is of President McKinley and Vice President Garrett A. Hobart as they travel through Sharpsburg on the way to visit Antietam Battlefield in the late 1890s. (Courtesy *Maryland Cracker Barrel*.)

Many farms were pressed into service as makeshift hospitals to handle the wounded during the fighting in the region. One of these was the makeshift "Smoketown Hospital." Smoketown Road provided an easy route for transporting wounded because it led directly from the Dunker Church. Smoketown was only four homes and a school in 1862, but it saw more than its share of wounded after the battle. (Courtesy Washington County Historical Society.)

Civil War veterans returned to Sharpsburg and Antietam Battlefield in large numbers each year for memorial services and reunions. Today, an annual illumination of Antietam National Battlefield still remembers the sacrifices of these soldiers who fought to preserve the freedom Americans enjoy. (Courtesy *Maryland Cracker Barrel.*)

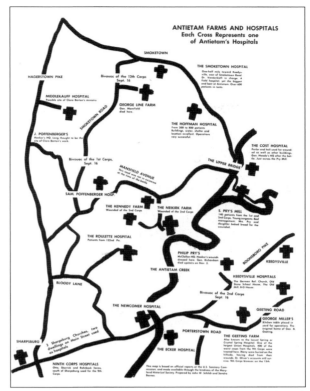

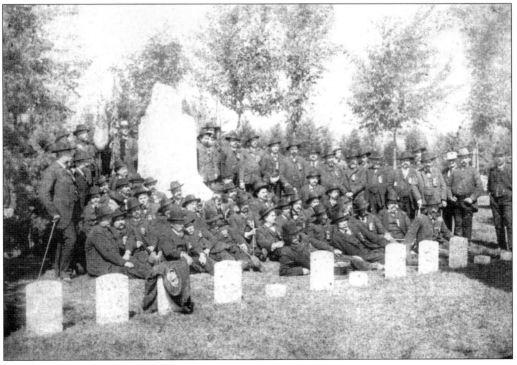

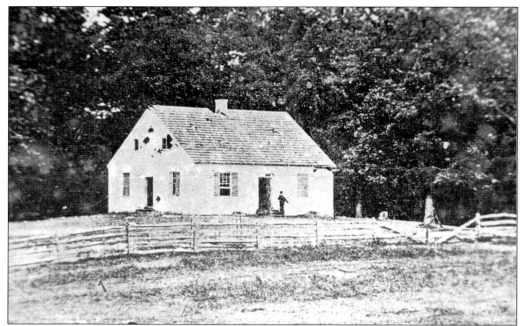

The Dunker Church was built in 1852 and gained its place in history on September 17, 1862, known as the bloodiest day of the war. This photo, which was taken after the battle, shows the damage sustained by cannon fire. (Courtesy Washington County Historical Society.)

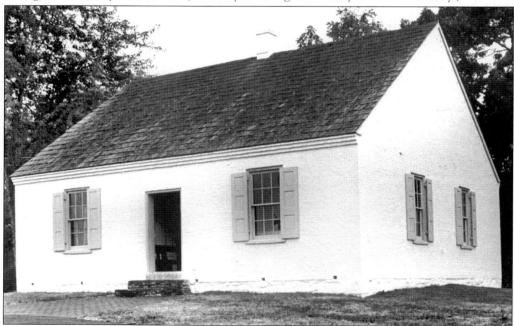

Taken on September 13, 1987 during the 125th Anniversary of Antietam, this photo shows the Dunker Church as it appears today. The Washington County Historical Society purchased the land in 1951 and the church was rebuilt in 1961. The church is now a much-visited site during tours of the battlefield. (Courtesy Washington County Historical Society.)

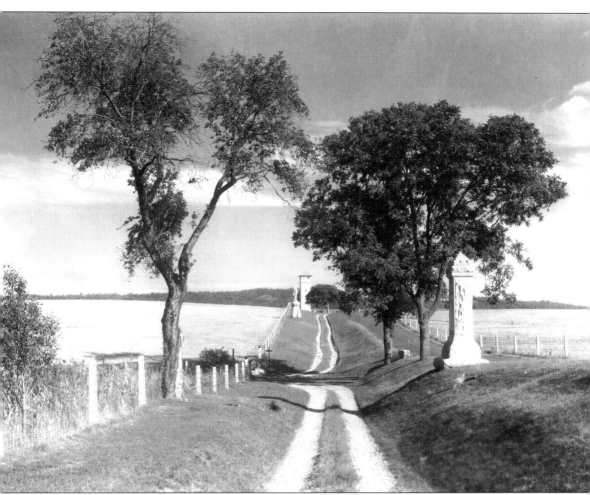

This sunken road near the Dunker Church was once a road leading from Sharpsburg to Boonsboro, Maryland. On September 17, 1862 so much blood was spilled from the dead and wounded soldiers that the road was renamed Bloody Lane. The observation deck visible at the end of the lane was built in 1896 and was used by the U.S. Military Academy to better illustrate troop movements around the area. (Courtesy Washington County Historical Society.)

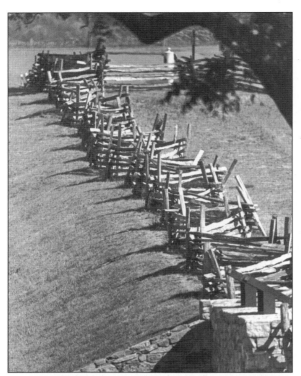

Taken on September 13, 1987 during the 125th Antietam Anniversary events, this picture shows the now tranquil Bloody Lane, a scene of much carnage during the Battle of Antietam. (Courtesy Washington County Historical Society.)

Candles glow in luminaries placed in the snow at the annual illumination at Antietam National Battlefield. Cars come from all over to drive through the battlefield after dark to see this spectacular site. (Courtesy *Maryland Cracker Barrel.*)

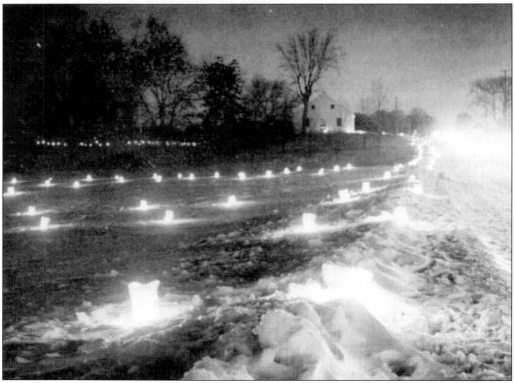

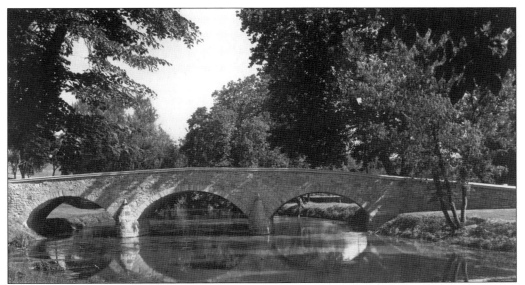

Erected in 1836 by bridge builder John Weaver at a cost of approximately $2,300, Burnside Bridge (also known as the Lower Bridge) takes its current name from the Union general Ambrose Burnside who spent most of the morning on September 17, 1862 trying to get his troops across. Just one of eight bridges built by Weaver in Washington County, Burnside Bridge today has been beautifully restored to its original condition. (Courtesy Washington County Historical Society.)

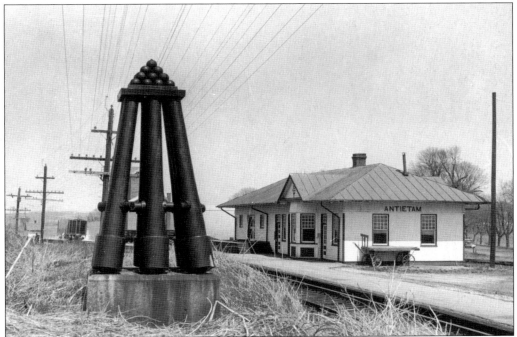

In 1959, the Antietam Railroad Station was still the home of the cannonball monument. The monument was later dismantled and donated to the Antietam National Battlefield Park. (Courtesy Western Maryland Room, Washington County Free Library.)

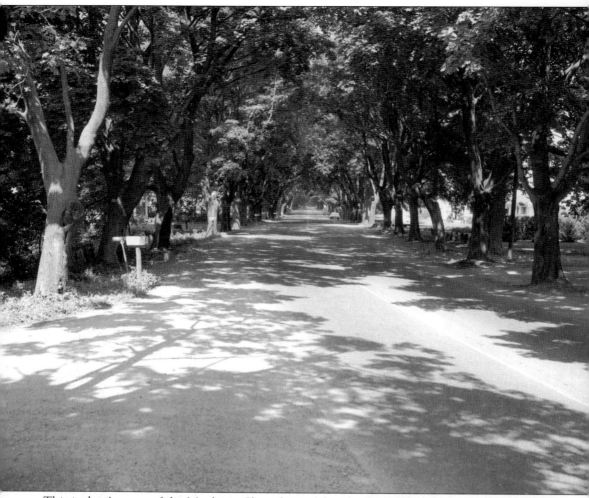

This is the Avenue of the Maples in Sharpsburg. After the Civil War, the town of Sharpsburg had been forever changed by the ravages of war and was now a pilgrimage site for veterans and widows. The town welcomed all newcomers and planted Norway maples to shade the road to the National Cemetery from the train station. There was always a dipper hanging at the Great Spring and many would stop there to refresh themselves and talk with others. (Courtesy Washington County Historical Society.)

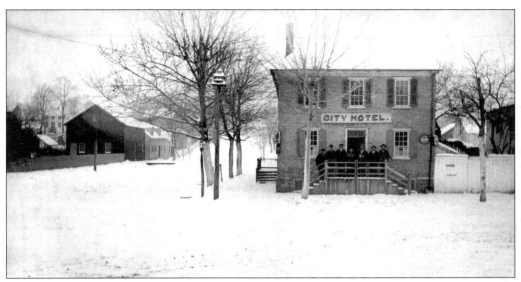

Some men stand on the porch of the City Hotel in Sharpsburg and appear to be waiting for their horse-drawn sleighs to pull up in the snow. (Courtesy Western Maryland Room, Washington County Free Library.)

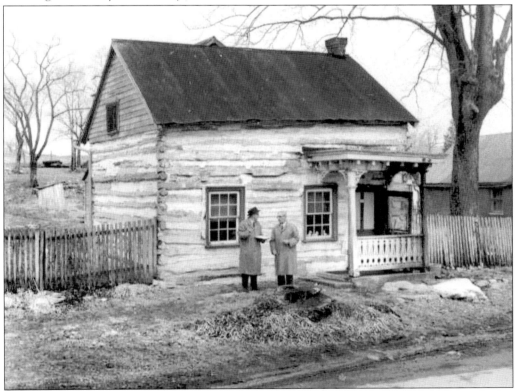

Taken in 1960, this photo shows a field surveyor interviewing the longtime resident of a log house built over 100 years earlier in Sharpsburg. Note the outhouse still present out back. (Courtesy Western Maryland Room, Washington County Free Library.)

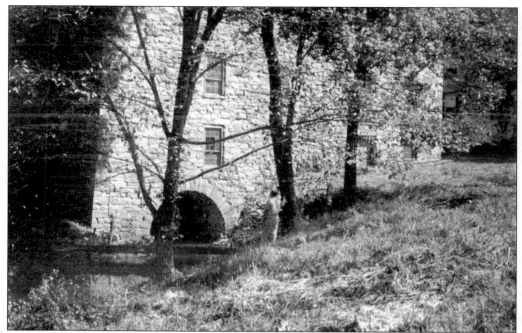

Located three miles south of Sharpsburg, the remains of Antietam furnace stand on a hill above Antietam Creek. The furnace of the Antietam Iron Works was completed about 1767–1768. Antietam Village grew up around the furnace and was a thriving community. (Courtesy Washington County Historical Society.)

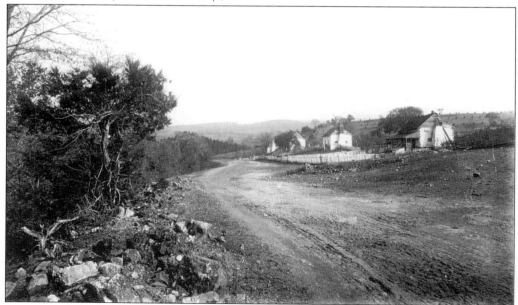

During the Revolutionary War, cannonballs used by George Washington's troops were made at the furnace of the Antietam Iron Works by about 500 workers. Parts were also made here for James Rumsey's steamboat. The iron works closed in 1857. (Courtesy Washington County Historical Society.)

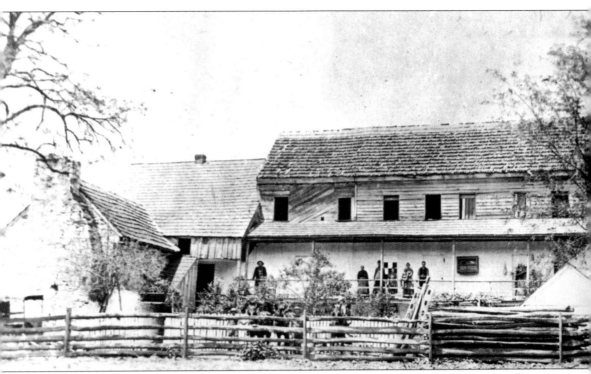

Located just two miles southeast of Sharpsburg was the popular resort of Belinda Springs. Once one of the most famous resorts and spas in the eastern United States, it was visited by senators and others from the nation's capital who came to partake of the medicinal sulphur and limestone waters. Built by Jacob Gardenhour in 1822, the hotel was the setting for ballroom dancing, entertainment by actors from New York, and many other social events. It is rumored that even George Washington was once a guest. In 1832 there was a cholera breakout among workmen on the nearby C&O Canal and the resort closed and faded into the past. (Courtesy Washington County Historical Society.)

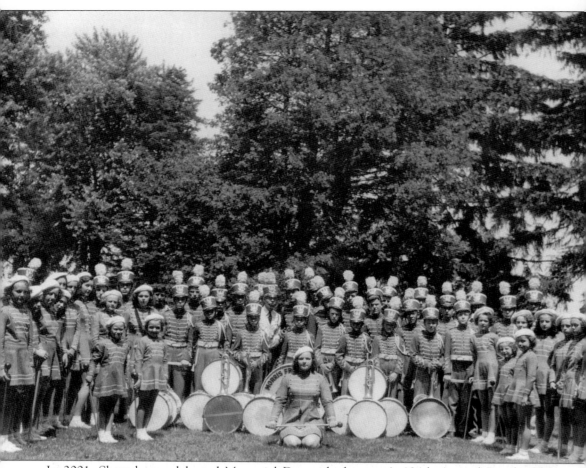

In 2001, Sharpsburg celebrated Memorial Day with the town's 134th Annual Parade. This photo of the Sons of the American Legion Drum Corp was taken at the parade on May 30, 1944. (Courtesy Western Maryland Room, Washington County Free Library.)

Two

Hancock,
Clear Spring, and
Fort Frederick

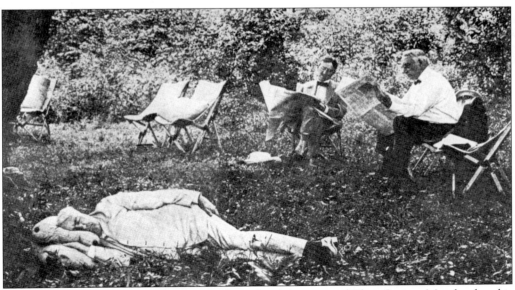

The small town of Pecktonville along Licking Creek lies west of Clear Spring, Maryland and is the site of Camp Harding. In July 1921, President Warren G. Harding camped here with Thomas Edison, Harvey Firestone, and Henry Ford on one of their trips designed to increase the popularity of auto touring. Here we see Edison napping while Firestone and President Harding read their newspapers. (Courtesy *Maryland Cracker Barrel*.)

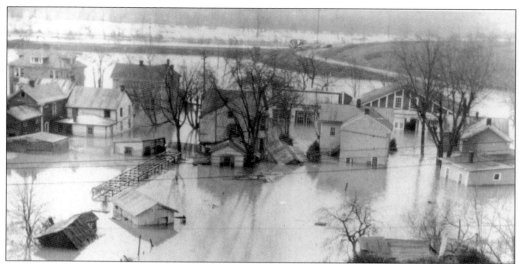

On March 18, 1936, a great flood washed through Hancock, Maryland. Hancock is at the far western edge of Washington County and sits on the Potomac River at the narrowest point in the state of Maryland. The town was named for Joseph Hancock, a ferryman who carried people and goods across the Potomac. (Courtesy Washington County Historical Society.)

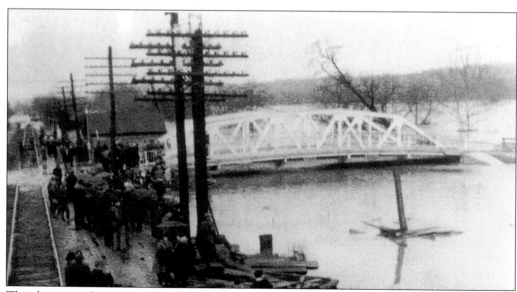

This dramatic photo of the flood of 1936 was taken along the rail tracks in Hancock. (Courtesy Washington County Historical Society.)

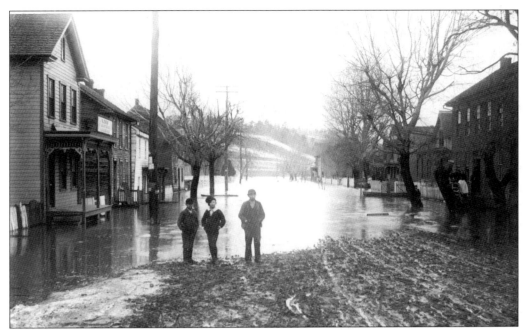

These boys are standing high and dry at the west end of Hancock following a flood in March 1902. Note the level of the water creeping up the sides of the buildings. (Courtesy Washington County Historical Society.)

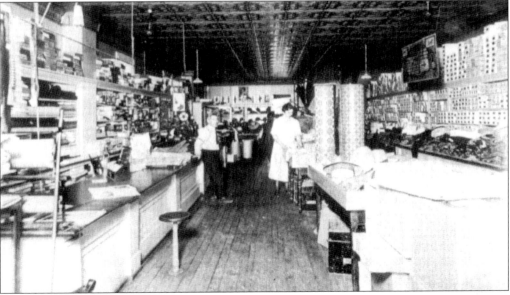

H. Nathan Rosen opened his store on the corner of Taney Alley and Main Street in Hancock in 1919. The business thrived and made it through the Depression intact. Rosen's sons, Norman, Robert, and Odell joined their father in business in the 1930s and 1940s. By 1950 there were stores in Mercersburg, Pennsylvania, Charles Town, West Virginia, and Hancock and Hagerstown, Maryland. This photo shows Nathan Rosen on the left in the Hancock store in 1920. (Courtesy *Maryland Cracker Barrel*.)

The Hancock Mail Wagon is stopped at a tollgate on the National Road on June 20, 1904. Note the old lamppost just to the left of the horse's head. The National Pike passed through six states—Maryland, Pennsylvania, West Virginia, Ohio, Indiana, and Illinois— and opened up the route west. (Courtesy Washington County Historical Society.)

This photo provides a view of Hancock's Main Street as it appeared in 1922. (Courtesy *Maryland Cracker Barrel.*)

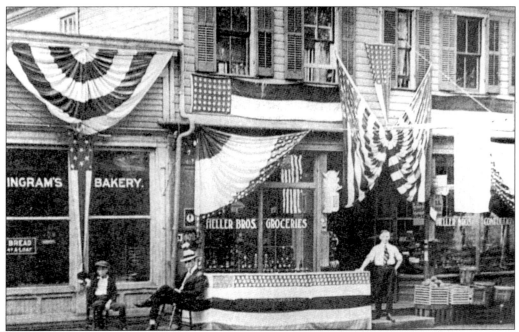

On July 4, near the end of World War I, Lewis Heller stands in front of his grocery store and J. Roy Ingram, the seated man with the hat, sits in front of his bakery in Hancock. (Courtesy *Maryland Cracker Barrel.*)

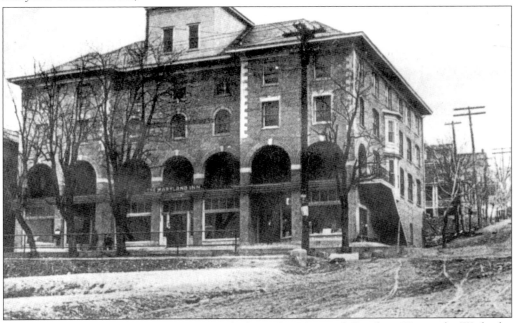

The long-gone Maryland Inn once stood along the National Road in Hancock. With the construction of the interstate highway system, many of the businesses that were scattered along the National Road found their trade declining as traffic moved away from the old roads to the new. (Courtesy *Maryland Cracker Barrel.*)

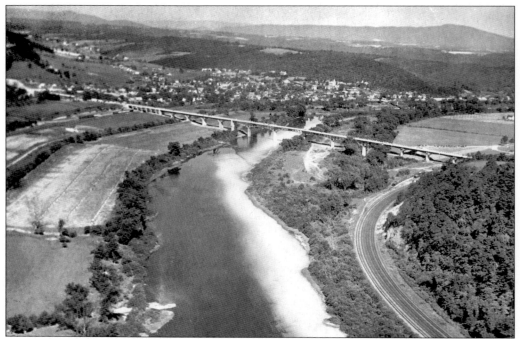

This aerial photo gives a wonderful view of the Hancock Bridge and the surrounding area. Note the rail tracks along the right and the peaceful countryside around the town. (Courtesy Washington County Historical Society.)

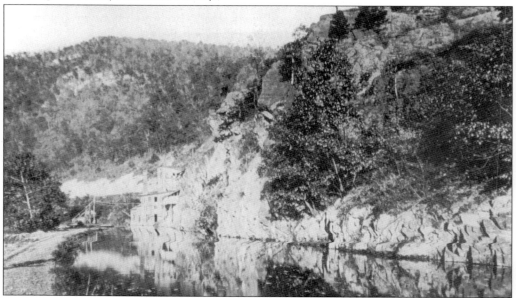

Just west of Hancock, along the C&O Canal was the Roundtop Cement plant. The mill was originally built to supply cement used in completing the western end of the canal. After the construction of the canal was stopped in 1850 at Cumberland, Maryland, the plant continued to operate for approximately another 50 years. (Courtesy Western Maryland Room, Washington County Free Library.)

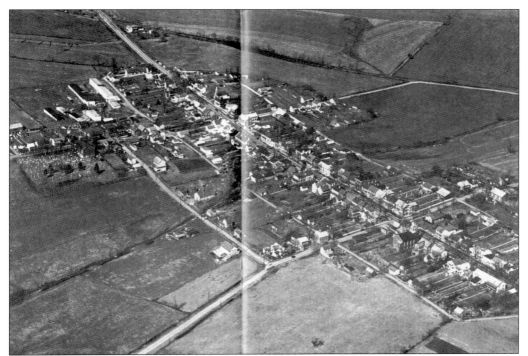

Twelve miles west of Hagerstown is the town of Clear Spring, Maryland. Martin Myers, who was attracted by a nearby spring of sparkling water, founded the community. This aerial view of the small town was taken c.1959. (Courtesy *Maryland Cracker Barrel.*)

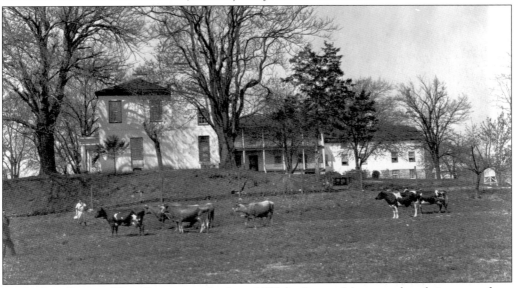

Stafford Hall, near Clear Spring, was built in 1832 by Barnes Mason and took its name from the ancestral home of the Masons in Staffordshire, England. The house was the summer home of William T. Hamilton, governor of Maryland from 1880 to 1884. Hamilton was a Washington County native who was born in Boonsboro, Maryland. (Courtesy Washington County Historical Society.)

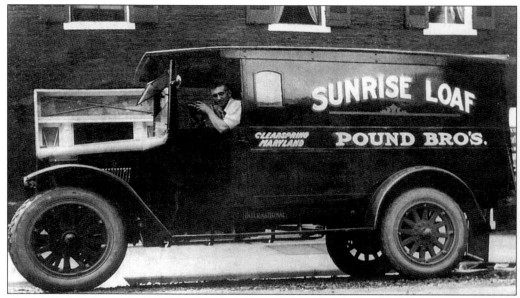

Originally opened in 1916 with the name Pound and Beard, the Clear Spring bakery that produced Sunrise Loaf bread was known throughout the county. When Beard left the area the partners changed and the name became simply Pound Brothers. Delivery trucks carried the bread to markets around Washington County. The bakery closed in 1940. (Courtesy *Maryland Cracker Barrel*.)

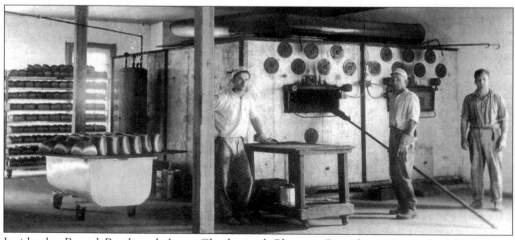

Inside the Pound Brothers bakery, Charles and Clarence Pound are pictured with Armond Rhodes. Large loaves of the bread are stacked on racks to the left. During President Warren G. Harding's famous auto trip through the area in 1921 with Henry Ford, Thomas Edison, and Harvey Firestone, Clarence Pound took bread to the campers from the bakery. (Courtesy *Maryland Cracker Barrel*.)

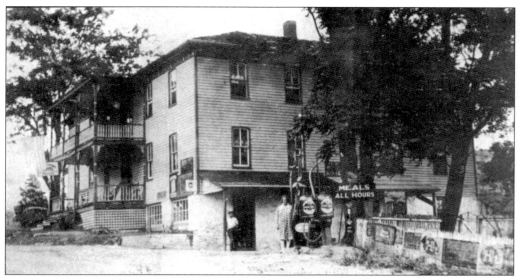

West of Clear Spring stood the Indian Springs Hotel that was among the many popular stopping places for travelers along the National Pike. Note the sign that advertises "meals all hours." (Courtesy *Maryland Cracker Barrel*.)

This community kitchen on Cumberland Street in Clear Spring served as a canteen for soldiers stationed nearby during World War I. Women came to the kitchen to can fruit and vegetables for their families and for the troops using a new steam pressure cooker on loan from the Agriculture College of Maryland. After the war, the building became the Clear Spring Library. (Courtesy *Maryland Cracker Barrel*.)

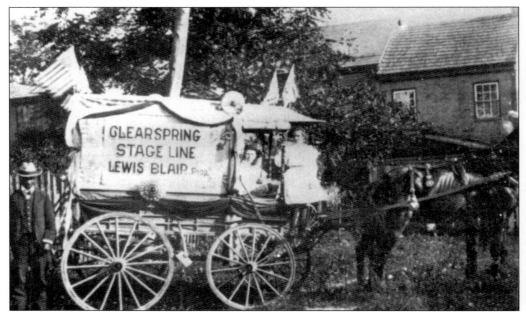

Lewis Blair operated a stagecoach line in Clear Spring around the turn of the 20th century. Until the time around the Civil War stagecoaches were the primary mail carriers and businessmen depended on the coaches to receive economic news. National newspapers also made their way to rural areas via the stagecoach. (Courtesy *Maryland Cracker Barrel*.)

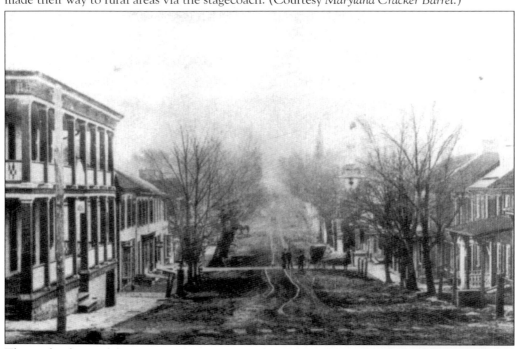

This early photo of downtown Clear Spring shows the American Hotel on the left. The hotel was a popular eating place for many and a favorite of statesman Henry Clay. (Courtesy *Maryland Cracker Barrel*.)

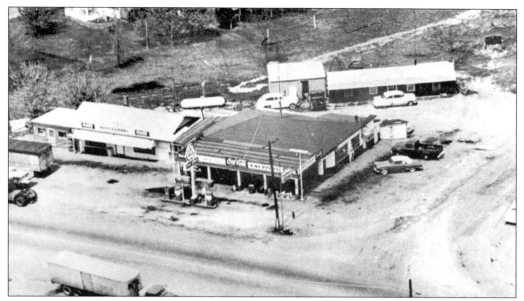

Earl Knepper operated a filling station/lunchroom/souvenir shop in Clear Spring. In a June 27, 1954 issue of the *Baltimore Sun Sunday Magazine*, the popular spot on U.S. Route 40 was referred to as a "monument to the insanity of the Great American Tourist." The shop was packed with items to entice browsing tourists and Earl himself was always open for a bit of whimsy—one advertisement shows him promoting the restaurant's free coffee astride a life-size concrete horse known as Lady Wonder, The Talking Horse. (Courtesy Western Maryland Room, Washington County Free Library.)

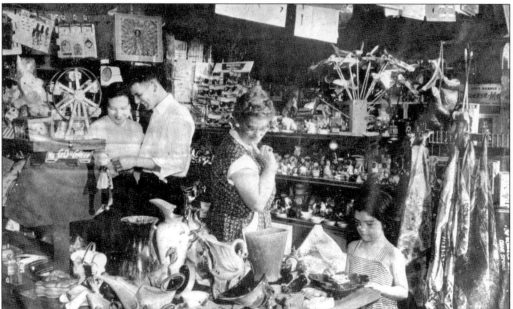

This is an interior view of Knepper's restaurant. Note the wide variety of souvenirs and other trinkets all designed to capture the interest of customers. (Courtesy Western Maryland Room, Washington County Free Library.)

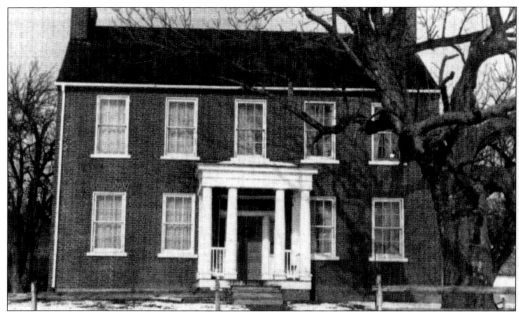

Built in 1813 by Jonathan and Anne Nesbit, Plumb Grove is situated on the northern edge of Clear Spring, Maryland. The mansion is a testament to the success of a local preservation group who spent years trying to acquire the home. Today, the restored mansion is home to the Clear Spring Historical Society. (Courtesy *Maryland Cracker Barrel*.)

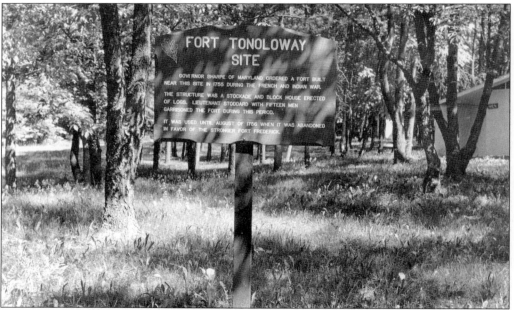

A wooden fort was built near Hancock in 1755 during the French and Indian War. The log structure, known as Fort Tonoloway, was used as a blockhouse and stockade. The fort was abandoned in 1756 when the stronger Fort Frederick was erected. Fort Tonoloway is long gone, but a state park was built on the site and used for many years until it too was abandoned. (Courtesy Western Maryland Room, Washington County Free Library.)

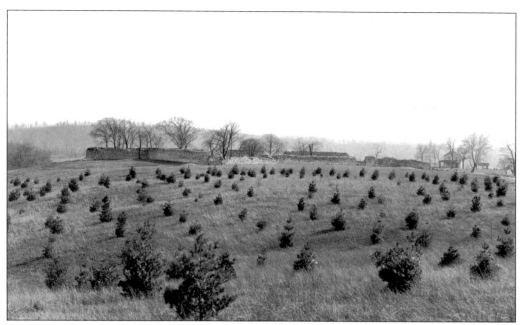

Fort Frederick, now in ruins, is located near Big Pool, Maryland. Construction of the fort began in 1756 in response to settlers' concerns of impending attacks by Native Americans during the French and Indian War. The fort was later used during the Revolution to house prisoners of war, and during the Civil War it guarded the C&O Canal and the Western Maryland Railroad (Courtesy Western Maryland Room, Washington County Free Library.)

This old photo of Fort Frederick shows the large barn that had been built against the northwest corner of the fort. The enclosure made by the fort served as a pasture. (Courtesy Western Maryland Room, Washington County Free Library.)

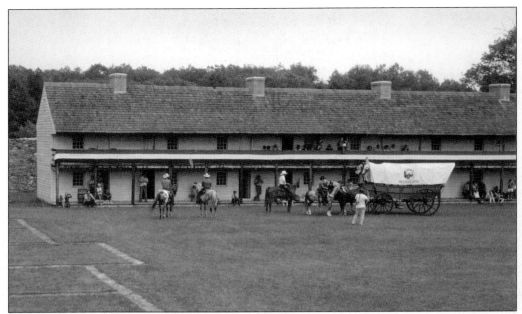

Fort Frederick is one of the few sites of the French and Indian War that remain anywhere in the United States. This photo shows a reenactment taking place at the fort. The fort, as well as the surrounding area, is also a conservation center and a bird sanctuary. (Courtesy Western Maryland Room, Washington County Free Library.)

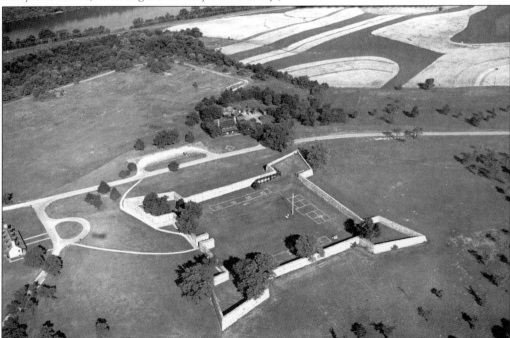

Fort Frederick deteriorated and lay in ruins after the Civil War until the state bought the land and began restoration in 1932. Work was done by the CCC and the state park was opened to the public in 1933. (Courtesy Washington County Historical Society.)

Woodmont Rod and Gun Club is located just west of Hancock and has long been a presidential hunting retreat. The exclusive hunting and fishing club was founded in 1870 and the first clubhouse was a 140-year-old log cabin. The present structure, seen in this photo, was built in 1929. All the materials to build the lodge, with the exception of the roof tiles, were obtained directly from the Woodmont property. Six presidents have spent time relaxing at the wooded retreat: James A. Garfield, Chester A. Arthur, Grover Cleveland, Benjamin Harrison, Herbert Hoover, and Franklin D. Roosevelt. (Courtesy Washington County Historical Society.)

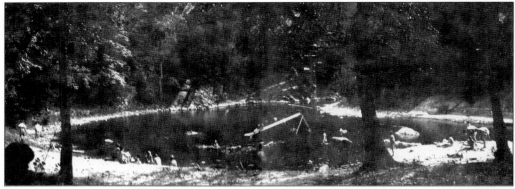

From 1927 to 1947 a Boy Scout camp existed at Pearre, Maryland, west of Hancock along Sideling Hill Creek. Camp Sinoquipe later relocated to Fort Littleton, Pennsylvania where the original camp song was still sung. This view from the 1930s shows the old swimming hole at the camp along the creek. (Courtesy *Maryland Cracker Barrel.*)

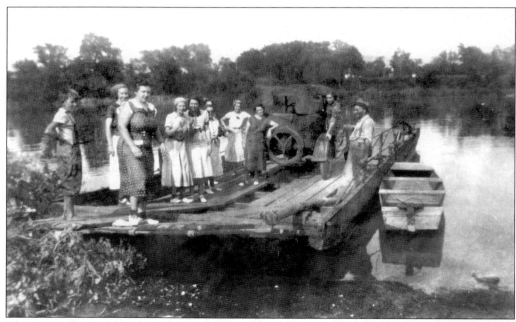

This 1936 photo shows the Big Pool-Cherry Run ferry, which ran from Big Pool, Maryland across the Potomac to Cherry Run, West Virginia. The ferry operator in the photo is C.C. French. Located near Fort Frederick State Park, Big Pool is on the Brosius River. (Courtesy Western Maryland Room, Washington County Free Library.)

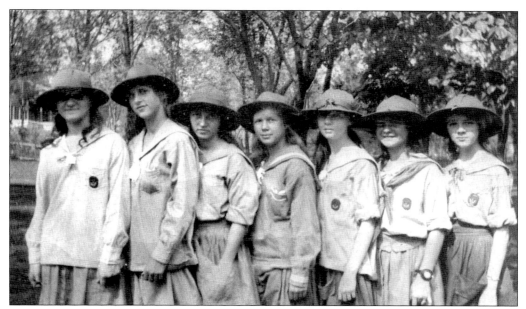

Girl Scouting, like Boy Scouting, was popular in Washington County. The girls of Red Rose Troop #1 at Big Pool in August of 1917, pictured from left to right, are Edna Stickell, Alice Hoover, Catherine Schindel, Mary White, Louisa Moller, Jona Miller, and Josephine Strite. Note the red roses on their uniforms. (Courtesy Western Maryland Room, Washington County Free Library.)

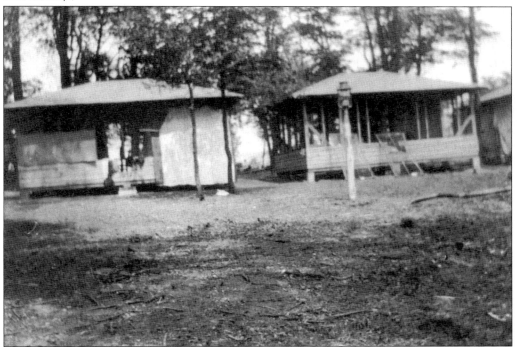

The Girl Scouts used these rustic cabins at their camp around 1918. (Courtesy Western Maryland Room, Washington County Free Library.)

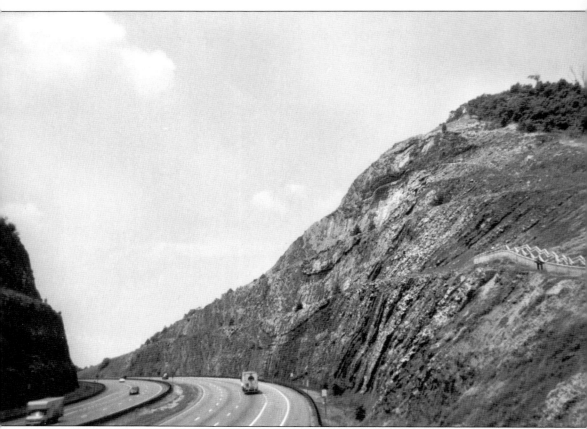

This striking V-shaped wedge cut out of Sideling Hill during the construction of Interstate 68 in the 1980s exposed layers of rock said to predate the dinosaurs by 100 million years. The cut is a geological treasure that gives testimony to the natural history of the region, which lies to the west of Hancock. The multi-colored layers of sediment that sweep up in both directions show the area was once part of a valley with jagged peaks. Today, the visitor center at Sideling Hill is a popular local attraction. (Courtesy Mary H. Rubin.)

Three
FUNKSTOWN AND HAGERSTOWN

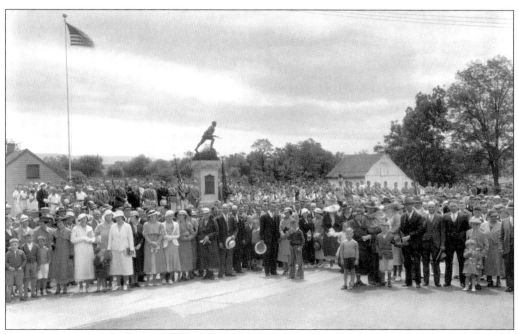

A war memorial to the fallen of World War I was dedicated in Funkstown, Maryland on July 23, 1921. One of the most notable landmarks in town, the memorial is located at the corner of Baltimore Street and Alternate Route 40. The crowd in the above photo were those who turned out for a memorial service on May 30, 1940 just prior to the United States entry into World War II. A Memorial Day parade was held in Funkstown every May 30th until 1949 when interest had declined after World War II. (Courtesy Washington County Historical Society.)

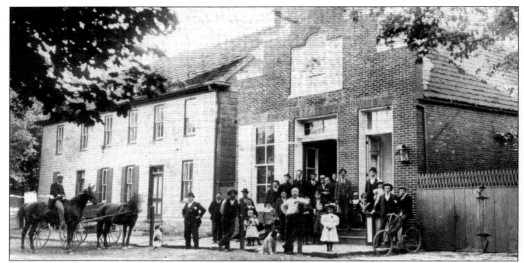

Funkstown is along the Old National Pike and became a stopping place for wagons and travelers from the 1790s to around 1839. When the B&O Railroad ran a line about a mile west of town it signaled the end of the busy trade. At one time, Funkstown also had a canal with locks to connect it with the C&O Canal, but, as this proved impractical, the barge's first trip was also its last. Here we see Williams Market, once a Funkstown landmark, on West Baltimore Street. (Courtesy *Maryland Cracker Barrel*.)

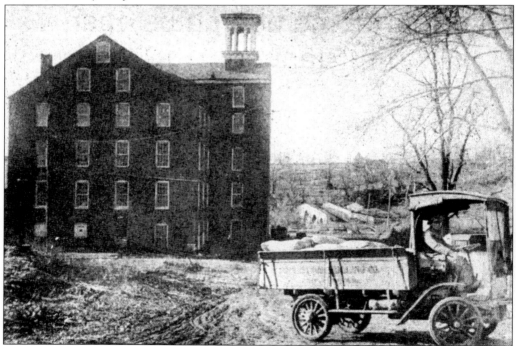

The Antietam Flour Mill, shown here in 1914, was built in 1867 and burned down in 1929. The mill stood between Antietam Creek and the site of the current day Funkstown Fire Hall. The one lane bridge over Antietam Creek, which was built in 1833, can be seen in the background. (Courtesy *Maryland Cracker Barrel*.)

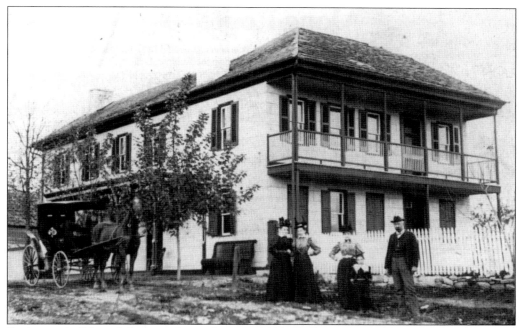

Funkstown's Edmar Manor is shown here in 1891. Built in 1790 of limestone and log, the manor has seven fireplaces as well as upstairs and downstairs verandas. One previous owner was a distant relative of Martha Washington and legend has it that some of her china once stood in the cupboards. (Courtesy *Maryland Cracker Barrel*.)

The large home known as the Chaney House on Baltimore Street in Funkstown, now Ruth's Antiques, was used as a hospital during the Civil War Battle of Funkstown. Gen. Robert E. Lee was retreating from Gettysburg, Pennsylvania and was assembling a nine-mile long battle line near Williamsport. To mask Lee's activities, J.E.B. Stuart engaged in a day-long battle on July 10, 1863 at Funkstown with Union general John Buford. Most of the fighting took place in the northeast section of town. (Courtesy *Maryland Cracker Barrel*.)

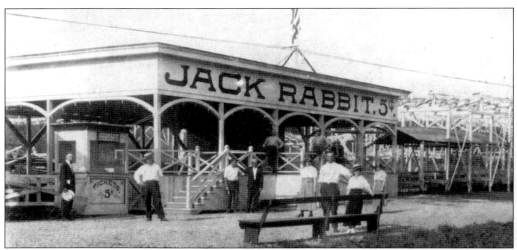

At the end of Funkstown's North Antietam Street was a swinging bridge that led across Antietam Creek to Electric Park Amusement Park in the late 1800s and early 1900s. Also known as Watts Park, Willow Grove, and Woodley Park, the popular attraction began in 1897 when the Hagerstown Railway extended service to Funkstown Bridge. (Courtesy *Maryland Cracker Barrel*.)

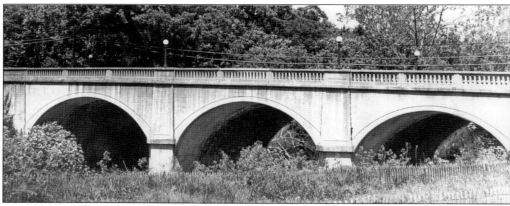

Built by James Lloyd in 1823, the three graceful arches of the Funkstown Turnpike Bridge span Antietam Creek in Funkstown, Maryland. One of 14 bridges over the creek, it is a local landmark and is a main thoroughfare between Funkstown and Hagerstown. The cars of the Hagerstown trolleys once traveled over the bridge en route to and from Funkstown. The bridge's original stone facade is only visible on one side. When the bridge was widened in the 1900s, the stonework on one side was covered with plain concrete arches. The bridge was the site of an uprising by the Irish immigrant workers who constructed the bridge. Military intervention was necessary to settle the conflict (Courtesy Washington County Historical Society.)

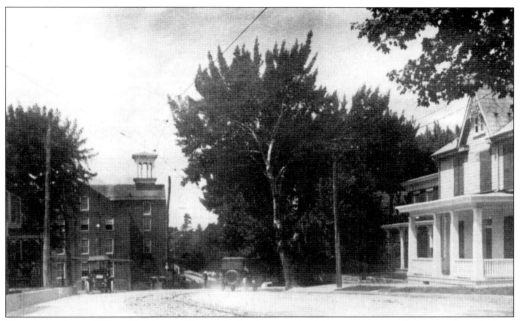

Here is a view of West Baltimore Street in Funkstown looking west toward the one-lane bridge on East Oak Ridge Drive. The gristmill that stood near the location of the current fire hall can be seen on the left. Note the trolley tracks running down the middle of the street. (Courtesy *Maryland Cracker Barrel.*)

This September 16, 1944 photo shows the Nightingale Inn in Funkstown on Baltimore Street. Note the tall old gas pumps out front. This building still stands today and looks much the same—minus the gas pumps and the signs for the Inn. (Courtesy Western Maryland Room, Washington County Free Library.)

Built in 1769 by Jacob Funck, the Funk House on West Baltimore Street is the oldest permanent residence in Funkstown. Jacob and Henry Funck, German immigrant brothers, came to the area and Jacob laid out a plan for a town in Frederick County that he named Jerusalem. When Frederick County was divided in 1776, Jerusalem became part of Washington County and was in the running with Hagerstown to be the county seat. Jonathan Hager beat Henry Funck to Annapolis and convinced the Maryland convention to choose Hagerstown, then known as Elizabethtown. Had things been different, perhaps Funkstown would have grown into a large town while Hagerstown remained small. The town of Jerusalem was incorporated in 1840 and the name was changed to Funkstown in 1854—a shortened version of the then commonly used name of Funck's Jerusalem Town. (Courtesy *Maryland Cracker Barrel*.)

This barn on the Artz farm stands just outside Funkstown on the Old National Pike. Believed to have been built in the late 1700s, the barn was the site of Jeb Stuart's right flank during the 1863 Battle of Funkstown. (Courtesy *Maryland Cracker Barrel*.)

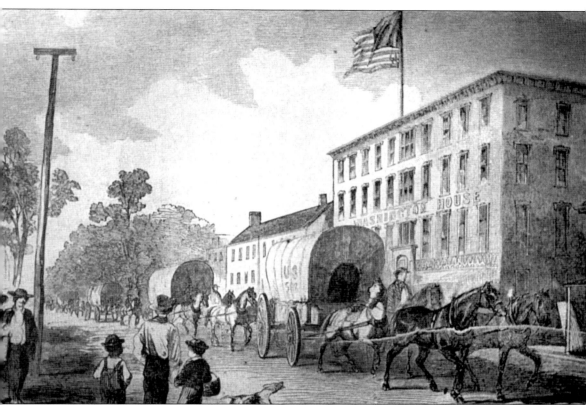

This picture appeared in *Harper's Weekly* on September 28, 1861. A Union supply wagon train is heading east on West Washington Street in Hagerstown. The wagons are passing in front of the imposing Washington House which was proclaimed to be "the finest hotel in the state outside Baltimore" when it opened in 1856. The Washington House, built on the site of the old Globe Tavern, burned down on May 29, 1879. The Baldwin House was later built on this site. (Courtesy *Maryland Cracker Barrel*.)

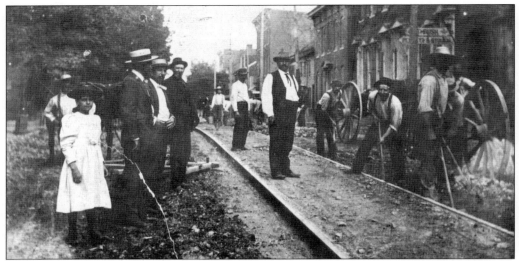

The trolley was a major fixture in Hagerstown since its beginnings in 1896. These men are laying trolley tracks on South Potomac Street in the early 1900s. The work sites garnered a lot of attention and onlookers. The trolley reached its height of service as the Hagerstown and Frederick Railway between 1913 and 1926. By 1904 the trolley was running 29 miles over mountainous roads to link Hagerstown and Frederick and a few years later the lines ran to Chambersburg, Pennsylvania. In the 1920s, the growth in popularity of cars and buses resulted in a decline of trolley passengers. Service was finally discontinued on the last of the operating routes in August 1947. (Courtesy *Maryland Cracker Barrel*.)

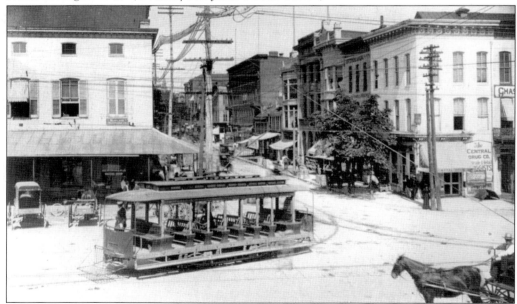

Taken about 1900, this photo shows the busy downtown Hagerstown Public Square. The Maryland Telephone Company building is above the trolley on the left and the Central Drug Company is across the street on the corner that would later be occupied by the Alexander Hotel. The edge of the Charles E. Shenk Piano store is just barely visible next to the drug company. (Courtesy Western Maryland Room, Washington County Free Library.)

In this rare 1864 photograph, Ulrick's Tobacco Store on West Washington Street in Hagerstown is visible. (Courtesy Western Maryland Room, Washington County Free Library.)

The eye-catching dappled horse in the photo below was a familiar site to Hagerstown's North End residents in 1925 when she pulled a delivery wagon for the Eldridge Dairy. The dairy acquired the horse when a circus that was in town could not pay its milk bill and gave the horse in payment. (Courtesy *Maryland Cracker Barrel.*)

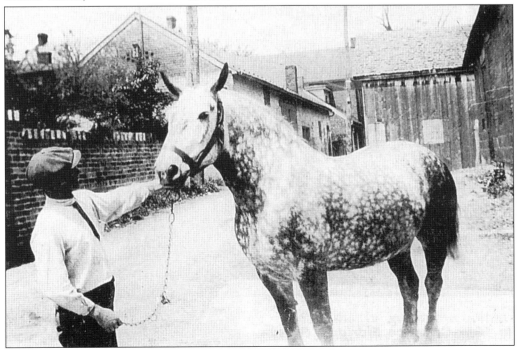

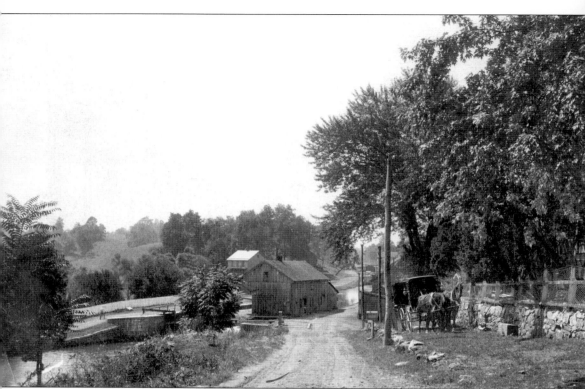

Taken *c.*1910, this vintage photo shows the Washington County Bookmobile at Tom Hassett's house at Four Locks at Lock 48 on the C&O Canal. Hagerstown town librarian Mary Titcomb began the world's very first book wagon service in 1904 when she began using the library wagon to send books to rural residents of Washington County. The book wagon served as a model for libraries around the world. Service was discontinued during the Great Depression and then again during the gas rationing days of World War II. The original wagon grew to a specially equipped truck to the present-day mammoth bookmobile outfitted for the needs of modern patrons. (Courtesy Western Maryland Room, Washington County Free Library.)

This is Washington Square in Hagerstown around 1900. Note the fountain in the center and the trolley tracks in the road. (Courtesy Western Maryland Room, Washington County Free Library.)

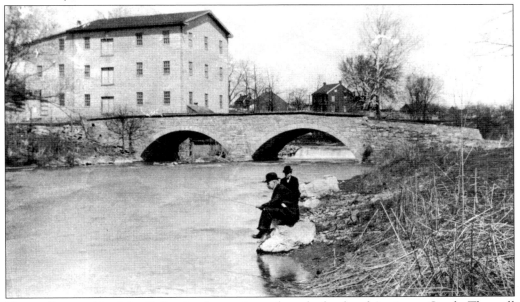

This mill, owned by John E. Rowland, was situated on the banks of Antietam Creek. The mill was torn down in 1925 and the land was taken over by the city of Hagerstown. The Municipal Electric Light Plant was built on the site on Cannon Avenue near Mount Aetna Road. (Courtesy Western Maryland Room, Washington County Free Library.)

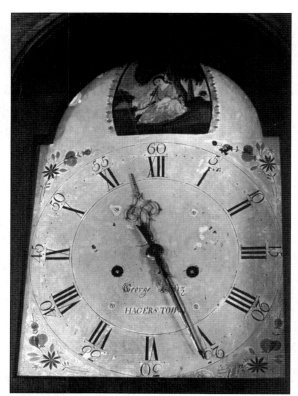

As the imprint on this clock clearly shows, Hagerstown was once home to clockmakers. This attractive clock was the work of George Woltz. Other early industries in the county included mills, forges, wheelwrights, blacksmiths, a brush factory, a brass foundry, a tannery, rope makers, and nail makers among others. (Courtesy Washington County Historical Society.)

The village of Bolivar is on the eastern side of the foot of South Mountain where the Old Hagerstown-Sharpsburg Road crossed the Old National Pike. This stagecoach traveling through the area says Hotel Hamilton on the side. The Hamilton was one of Hagerstown's main hotels of the day. (Courtesy Washington County Historical Society.)

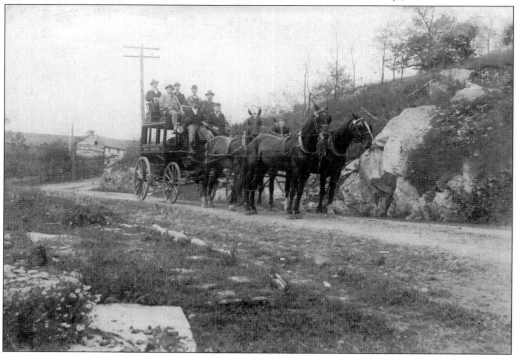

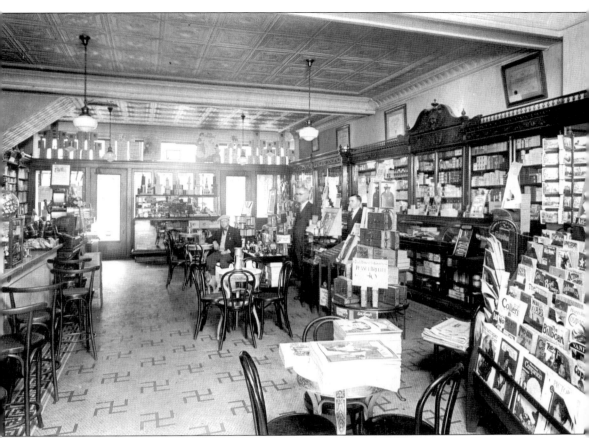

This photo showing the interior of Schindel's Pharmacy on Oak Hill Avenue in Hagerstown was taken in the early 1940s. Founded in 1897 by David P. Schindel, the store's original location was 47 South Potomac Street where Ben's Flower Shop is currently located. The store moved to the Oak Hill location in 1926 and has been there ever since, soda fountain still intact and in daily use. Behind the counter in the photo is Pappy Wilson. David Schindel Jr. and Arthur Harbaugh are on the right. Note the wide variety of magazine titles on sale. Pharmacist Chris Brown, who worked in the store as a teenager, owns Schindel's today. (Courtesy of Schindel's Pharmacy.)

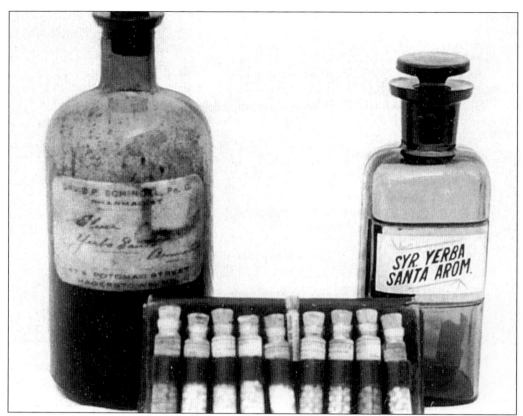

There are many old pharmacy bottles on display behind the soda fountain at Schindel's. The large bottle is dated 1900 while the smaller syrup bottle on the right dates from the 1930s. The small vials in the medical kit are from the 1920s. The contents of the vials include substances that are highly controlled today such as strychnine, morphine, and narcotic alkaloid of opium. (Courtesy of Schindel's Pharmacy.)

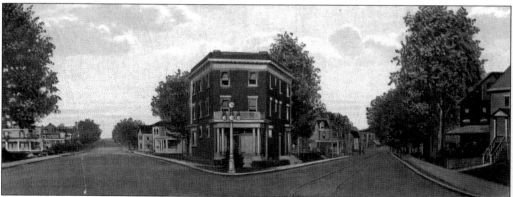

New York City isn't the only town to boast a Flatiron Building. This is a pre-1926 image of the Flatiron Building at the convergence of Oak Hill Avenue and North Potomac Street in Hagerstown. Note the trolley tracks curving off to the right. Schindel's Pharmacy would later occupy a building immediately in back of the Flatiron Building. (Courtesy of Schindel's Pharmacy.)

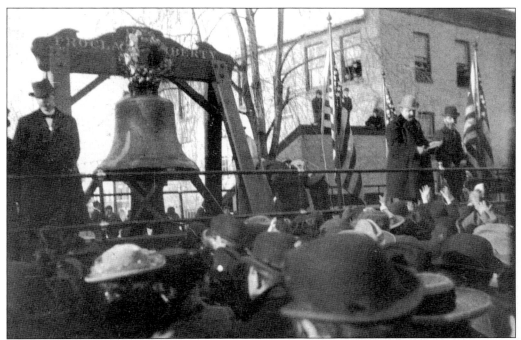

On January 6, 1902, courtesy of the Cumberland Valley Railroad Company, the Liberty Bell Special Train came to Hagerstown from Philadelphia, Pennsylvania. The Liberty Bell rode on an open car at the rear of the train, preceded by six Pullman cars with the escort committee. (Courtesy Western Maryland Room, Washington County Free Library.)

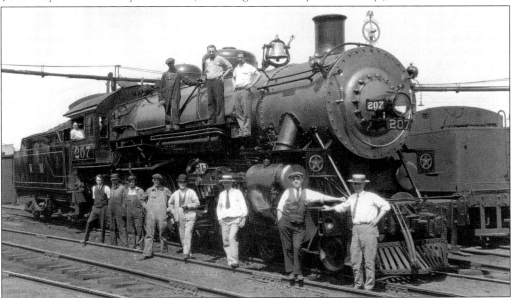

The Western Maryland Railroad was chartered in 1852 and, by 1887, there were two Western Maryland passenger terminals in Hagerstown, a freight station, train yards, and two grain elevators. Tracks from the Western Maryland served town from the north, south, and east and connected with all other railroads. (Courtesy Washington County Historical Society.)

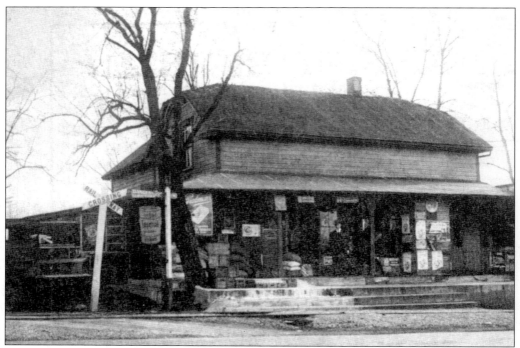

Taken in 1929, this photo shows the general store that Harry Snook operated from 1899 to 1935 at the corner of Virginia Avenue and what used to be Snook Road. Note the Williamsport trolley tracks running in front of the store. The building was torn down in 1965. (Courtesy *Maryland Cracker Barrel*.)

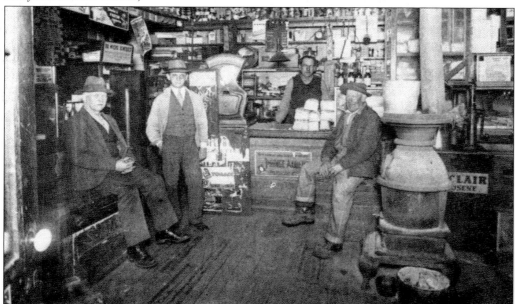

This is inside Harry Snook's store on Virginia Avenue around 1932. The men in the picture are, from left to right, William E. Emmert, Harry Clark, Harry Snook, and Fred Davis. (Courtesy *Maryland Cracker Barrel*.)

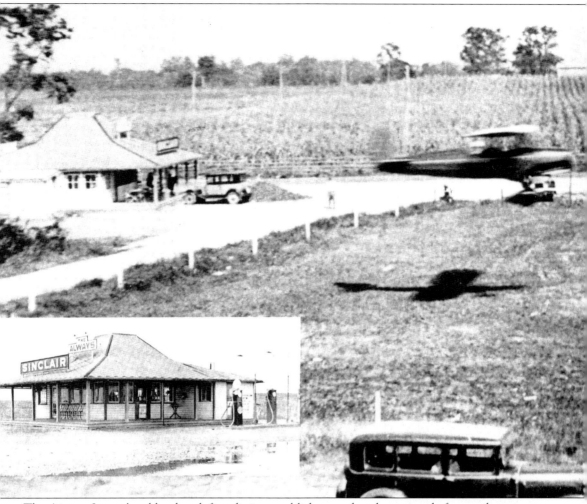

The Airport Inn, a local landmark fine dining establishment that draws people from miles away, had its beginnings as a lunchroom and Sinclair brand gas station known as "The Always" in the 1930s at the Hagerstown airfield. Note the shadow the landing plane in the larger photo casts while the inset shows a front view of the popular lunchroom that was frequented by Dick Henson, Hagerstown's "Mr. Aviation," among others. (Courtesy *Maryland Cracker Barrel*.)

Thousands of people throughout the region have anticipated the annual Hagerstown Alsatia Mummer's Parade for decades. The children waiting for the parade in this 1940 photo are standing on the street of Green Row that housed employees from the Security Cement Plant. (Courtesy *Maryland Cracker Barrel*.)

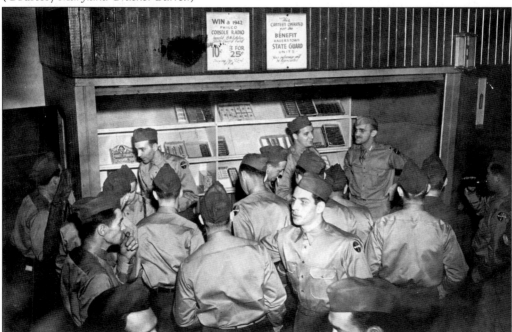

This World War II canteen was in operation to benefit Hagerstown State Guard units. Note the sign on the wall offering three chances for 25¢ to win a 1942 Philco Console radio. There were Washington County men at Pearl Harbor, and several World War II admirals and generals, among them Brig. Gen. Josef R. Sheetz from Williamsport and McArthur's chief of staff Richard Sutherland from Hancock, were born in Washington County. (Courtesy Washington County Historical Society.)

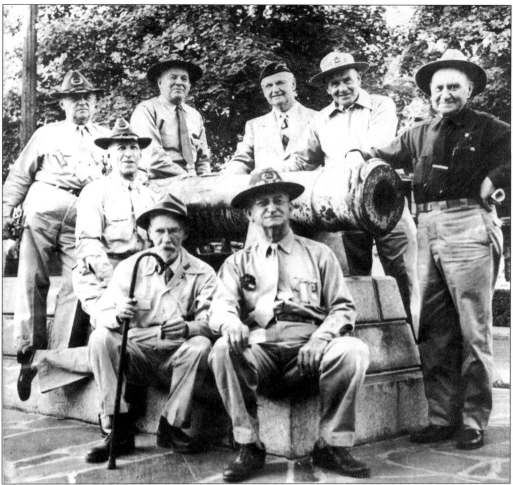

Spanish-American War veterans gathered in 1949 for their last major reunion. They are grouped around the bronze cannon captured during the 1897–1898 war. The cannon is mounted on the corner of North Potomac Street and North Avenue in Hagerstown and is the only memorial park in the United States dedicated to the veterans of this war. (Courtesy *Maryland Cracker Barrel.*)

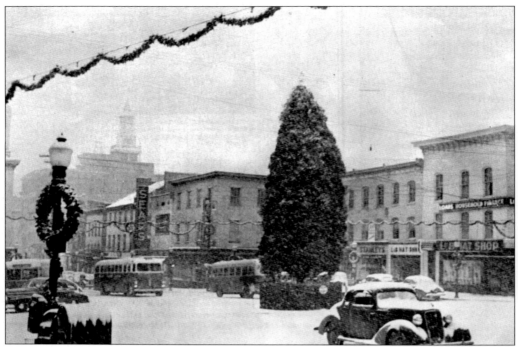

This wonderful winterland scene of Hagerstown's Public Square was taken in 1946. Sears department store was still downtown and can be seen through the swirling snow. Also note that traffic was moving both ways up and down Potomac Street in the years before one-way streets. (Courtesy *Maryland Cracker Barrel.*)

Taken February 6, 1957, this photo shows yet another quiet winter scene in Hagerstown showing the band shell in City Park. (Courtesy Western Maryland Room, Washington County Free Library.)

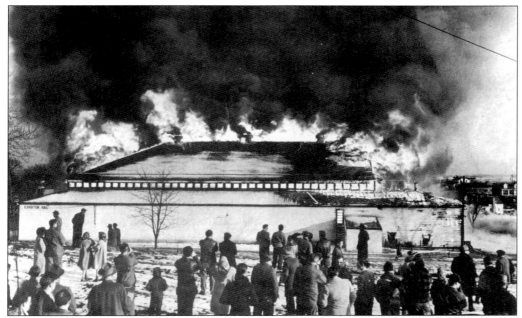

A raging fire burned down the Exhibition Hall at Hagerstown's Fairgrounds in December of 1950. The first Hagerstown Fair was held in 1854 at a spot along the Williamsport Pike (Virginia Avenue). The fair moved to the fairgrounds located between Mulberry and Cleveland Avenues in 1880. This grandstand would later be replaced by the concrete and steel structure that is on the site today. (Courtesy *Maryland Cracker Barrel*.)

This program cover comes from the 1890 Hagerstown Fair. Directions to the fairgrounds are given in the simple terms of "follow the crowd." Note in particular the warning at the bottom to beware of pickpockets. (Courtesy Western Maryland Room, Washington County Free Library.)

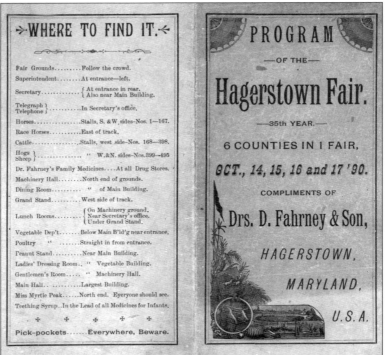

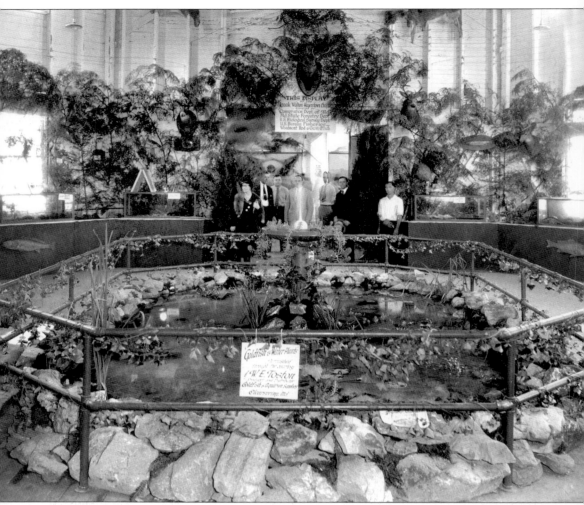

This elaborate display of goldfish and waterplants (from W.E. Toston's fish ponds and aquatic gardens in Clear Spring) was on exhibit at the Great Hagerstown Fair. The display was by the Hagerstown Chapter of the Izaak Walton League of America (IWLA) in conjunction with the Conservation Department of Maryland, Maryland State Forestry Department, United States Biological Survey Department, United States Bureau of Fisheries, and Woodmont Rod & Gun Club. Founded in 1922, the IWLA still has an active chapter in Washington County. (Courtesy Washington County Historical Society.)

Here is the Western Maryland Railway Station as it appeared on September 6, 1950. Today the building serves as the Hagerstown Police Department. (Courtesy Western Maryland Room Washington County Free Library.)

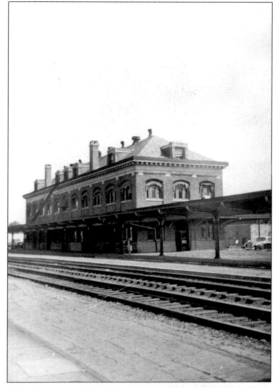

Hagerstown has had its share of well-known personalities visit throughout the years. In the image below, Dwight D. Eisenhower, the 34th president, is photographed as he comes down West Washington Street on September 25, 1952. Rep. Glenn Beall and Governor McKeldin are also in the car. Eyerly's, Woolworth's, and Fleisher's, can be seen behind the cheering crowds lining the street. (Courtesy Western Maryland Room Washington County Free Library.)

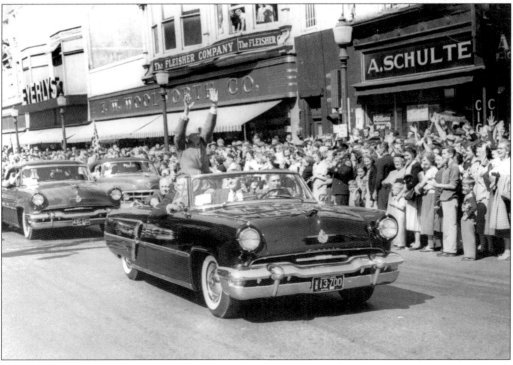

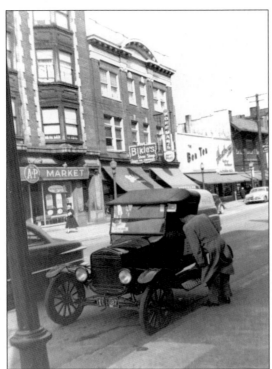

This photo of an old-fashioned car was taken on North Potomac Street on March 20, 1953. The car was taking part in the Sears Roebuck Old Times Days. Note the A&P market across the street with Bikle's Shoes, Hoffman's, and The Bon Ton up the street. (Courtesy Western Maryland Room Washington County Free Library.)

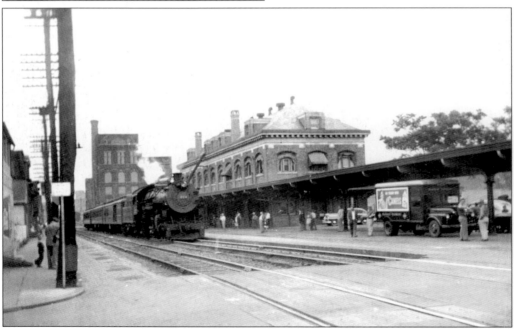

The last Western Maryland train from Hagerstown to Cumberland is shown here getting ready to leave the station on Memorial Day, May 31, 1953. With passenger service long discontinued, only rail freight travels through Hagerstown today. (Courtesy Western Maryland Room Washington County Free Library.)

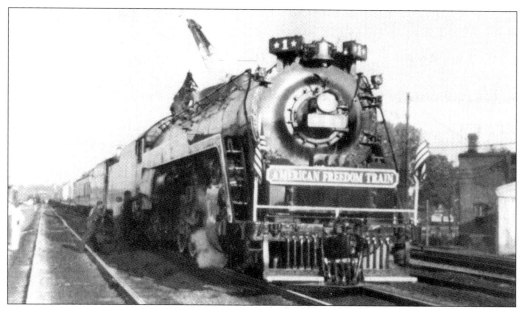

The Freedom Train traveled through Washington County on its way around the country in 1976 during the nation's Bicentennial Celebration. Here we see the engine pulling the train, proud flags waving. The 26-car train was pulled by a steam engine restored especially for the event. More than seven million Americans visited the train during its 48-state tour and millions more watched it roll by on the tracks. (Courtesy *Maryland Cracker Barrel*.)

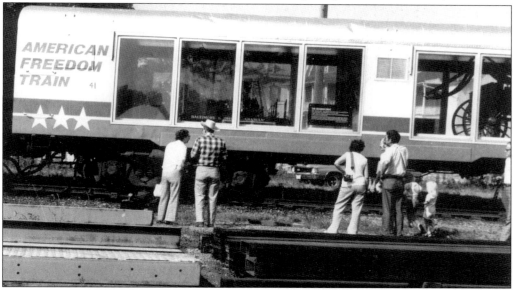

This is one of the cars on the American Freedom Train when it came to Hagerstown September 23–25, 1976. There were 12 display cars on the train—10 that visitors walked through and 2 more that were viewed from outside through large windows. Among the items on display were George Washington's copy of the Constitution, Judy Garland's dress from *The Wizard of Oz*, and a moon rock, along with many other pieces of Americana. (Courtesy Western Maryland Room, Washington County Free Library.)

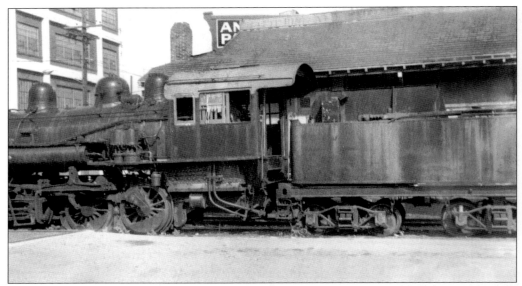

This photo of an old engine sitting at the B&O Terminal on West Antietam Street in Hagerstown was taken in the spring of 1976. Just a few years later both the trains and station would be gone to make way for the new Herald-Mail building. (Courtesy Western Maryland Room, Washington County Free Library.)

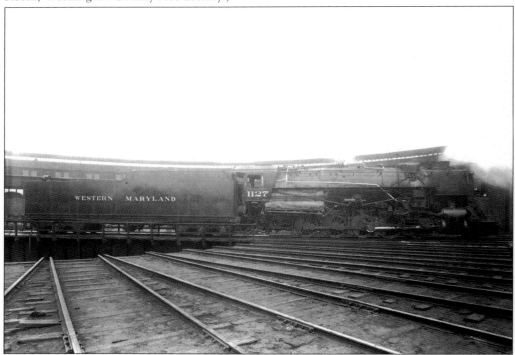

A Western Maryland locomotive sits on the roundtable at the Hagerstown Roundhouse. In spite of efforts by local groups to save it, too many environmental concerns existed and the roundhouse is now empty space on the site near Burhan's Boulevard. (Courtesy Washington County Historical Society.)

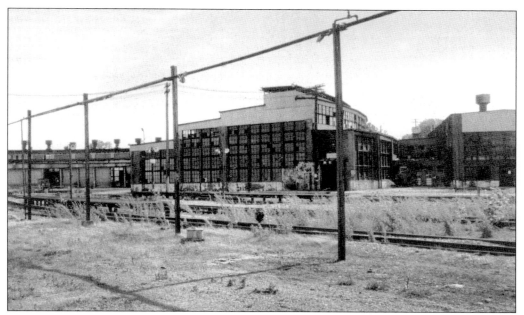

Taken in June 1988, this photo shows the railroad yards, buildings and roundhouse located between City Park and Burhans Boulevard in Hagerstown. Today, the buildings are gone and all that remains are the memories of the bustling roundhouse. (Courtesy Western Maryland Room, Washington County Free Library.)

In the 1980s, People's Drug Store was still on the left on the corner of West Washington and South Potomac Streets. Remember the old bus shelter on the corner of North Potomac and West Washington Streets and the stone pillars around each corner of the square? (Courtesy Western Maryland Room, Washington County Free Library.)

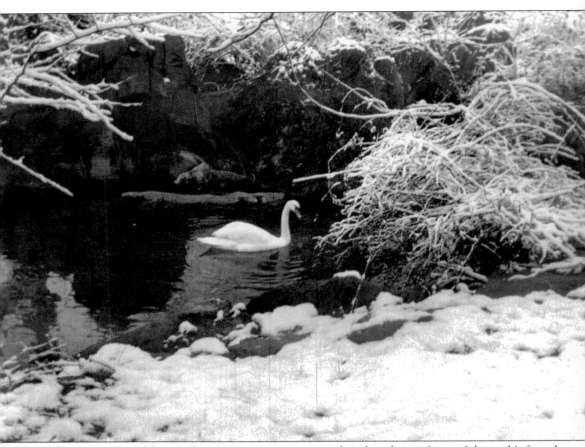

The tranquility of City Park in Hagerstown is captured in this photo of one of the park's famed swans. Hagerstown's 50-acre park is listed as one of the most beautiful in the country. The park offers many recreational opportunities, free concerts at the band shell during the summer, and several museums. The home of Hagerstown's founder, Jonathan Hager, is available for tours as is the Washington County Museum of Fine Arts and the Mansion House. The Mansion House has works by local and regional artists while the Fine Arts Museum has an impressive collection of American works as well as those of the old masters. (Courtesy Western Maryland Room, Washington County Free Library.)

Four

SMITHSBURG, FORT RITCHIE, AND PEN MAR PARK

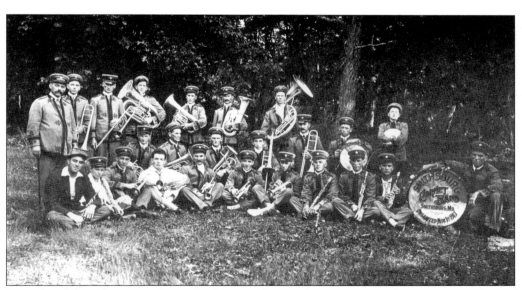

Town bands have been popular in Washington County for many years. Here we see members of the Smithsburg Coronet Band in a photo taken just after World War I. The band was formed in 1913 and played at area picnics as well as at Pen Mar Park. The bandleader, Daniel Pike, is the man standing on the left with the moustache. (Courtesy *Maryland Cracker Barrel*.)

This view of Smithsburg, Maryland gives credence to the rich, fertile soil found there. The town of Smithsburg dates back to 1813 when Christopher Smith bought a tract of land there. The town was incorporated in 1846. Although agriculture no longer holds the same role it did in earlier years, orchards and farming are still very important in the area. (Courtesy Washington County Historical Society.)

This photo of Smithsburg Square was taken *c.*1925. The historic Smithsburg Square slave block and bank can be seen on the left. (Courtesy *Maryland Cracker Barrel.*)

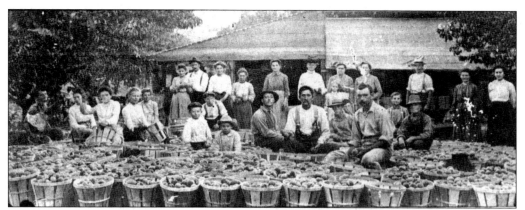

Founded as a town in 1813, Smithsburg's first post office opened in 1829. By the mid-19th century, local farmers had discovered that the soil was excellent for growing peaches. Now, more than a century later, orchards still dot the landscape. This photo shows peach pickers and packers at harvest time in Smithsburg, c. 1860. (Courtesy *Maryland Cracker Barrel.*)

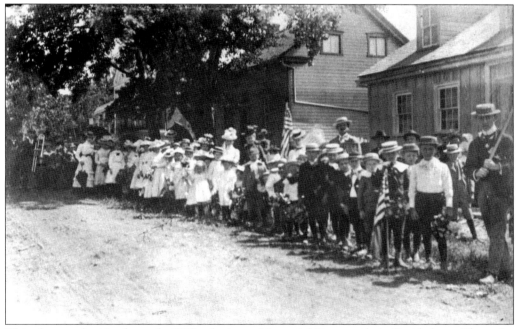

This photo, taken in the early 1900s, depicts a Memorial Day parade in Smithsburg. The quiet town had its own excitement during the Civil War when, on July 5, 1863, Gen. George Armstrong Custer and his men came through the town with several hundred Confederate prisoners. Residents of the town cheered for the general and set up an elaborate feast on tables hastily set up in the streets. Note the band just coming down the street on the far left. (Courtesy *Maryland Cracker Barrel.*)

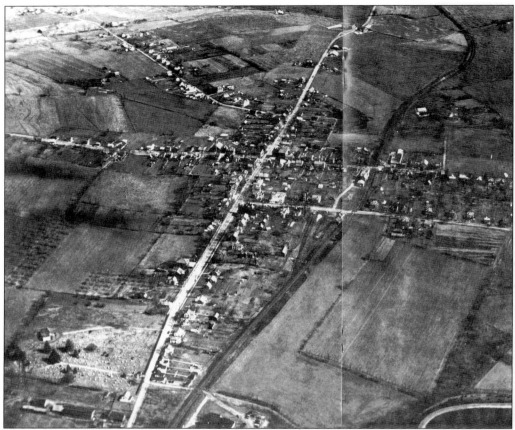

This aerial photo of Smithsburg was taken in 1960. Since that time, new highways, schools, homes, and businesses have been built in the area. (Courtesy *Maryland Cracker Barrel.*)

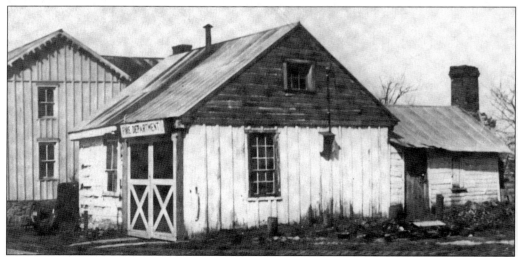

Smithsburg's first fire company was formed in 1931. The first fire hall was this garage labeled simply as "Fire Hall." (Courtesy *Maryland Cracker Barrel.*)

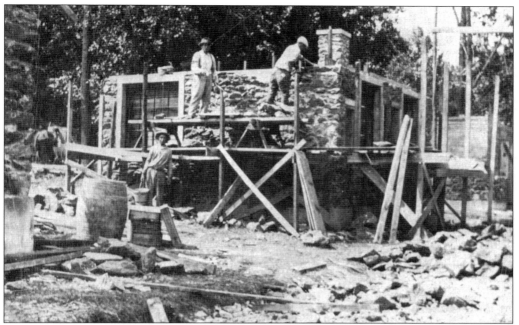

Fort Ritchie military installation was named for Albert C. Ritchie, governor of Maryland in 1926. Construction began on May 31, 1926 near the small community of Cascade, Maryland. Originally intended by the Maryland National Guard as a summer training ground for Maryland troops, the post was used as part of the headquarters of the Office of Strategic Service (OSS) during World War II as well as the Military Intelligence Training Center. (Courtesy *Maryland Cracker Barrel.*)

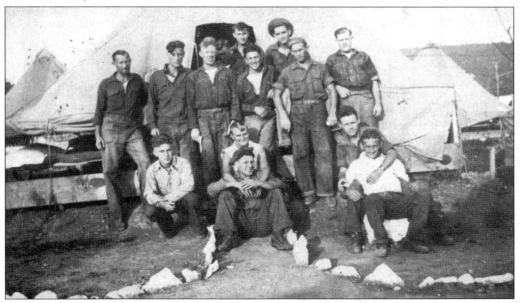

This photo shows young men at Camp Ritchie in 1933 shortly after joining the Civilian Conservation Corps. Earl Selby of Hagerstown is on the right in the back row. (Courtesy *Maryland Cracker Barrel.*)

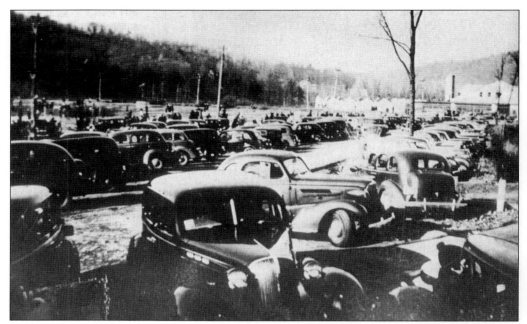

Look at this crowd of cars! These are the cars of all the people congregated at Fort Ritchie during the 1930s to ice skate on the lake. Today, Fort Ritchie has been closed and its future use has yet to be determined. (Courtesy *Maryland Cracker Barrel*.)

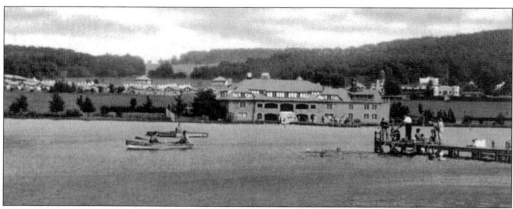

Taken in 1942, this photo shows Lake Royer and the clubhouse at Fort Ritchie. The post has a history of sharing recreational opportunities with the local public. During the Depression years motion pictures were shown nightly to the troops, and the gates were opened to include the local civilians. (Courtesy *Maryland Cracker Barrel*.)

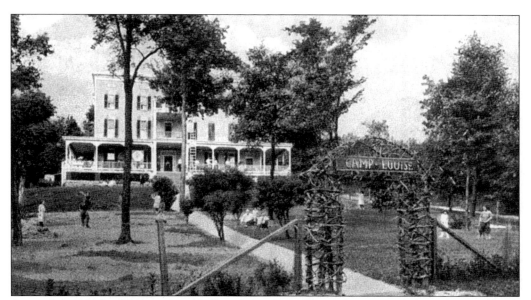

Opened in 1922 by the Aaron and Lillian Straus Foundation, Camp Louise has a long tradition of offering summer camp experiences to girls. Located in the Blue Ridge Mountains near Cascade and Fort Ritchie, the camp has served generations of girls and continues to be popular. (Courtesy *Maryland Cracker Barrel*.)

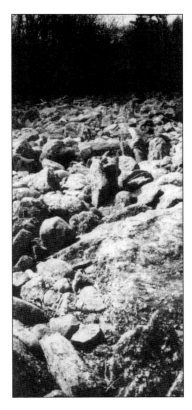

The Devil's Racecourse is what is known as a "boulder stream," a result of many rock falls during the freezing and thawing cycles of the Pleistocene Age over 100,000 years ago. When the "Rock River" is approached, water can be heard running, but it is under the rocks! The Devil's Racecourse is located near Fort Ritchie near the intersection of Maryland Route 491 and Ritchie Road. (Courtesy *Maryland Cracker Barrel*.)

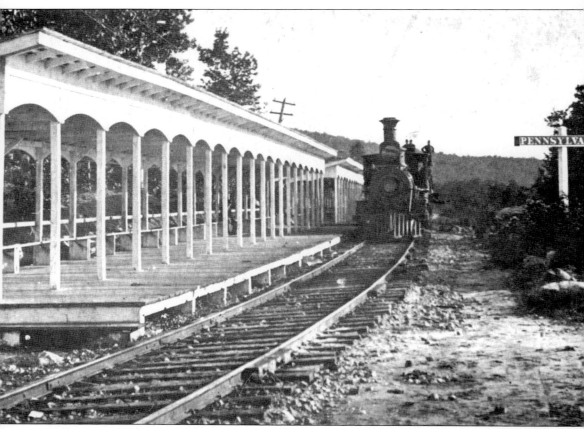

Opened in 1877 by the Western Maryland Railroad to generate excursion train business from Baltimore, Pen Mar Park sits high in the Blue Ridge Mountains on the border of Pennsylvania and Maryland on the Mason Dixon line and was one of the most famous resorts in the eastern United States. The amusement park contained, among other attractions, a roller coaster, movie theater, dance pavilion, a miniature train, food concessions, a playground and carousel, as well as the famous Blue Mountain House luxury hotel. Here we see a steam locomotive pulling up to the Western Maryland Railroad station at the park sometime in the late 1870s. (Courtesy *Maryland Cracker Barrel*.)

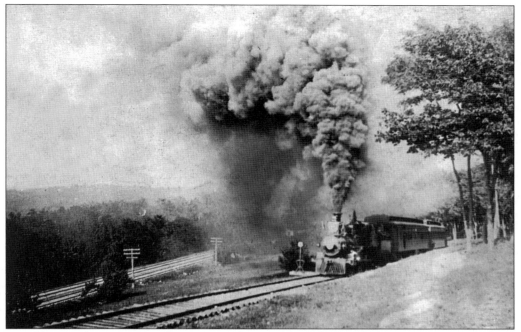

An old steam locomotive puffs its way to the Pen Mar siding with this excursion train to the park. During the summer, trains ran daily. The park's name is the contraction of Pennsylvania and Maryland because the park sits directly on their borders. (Courtesy Washington County Historical Society.)

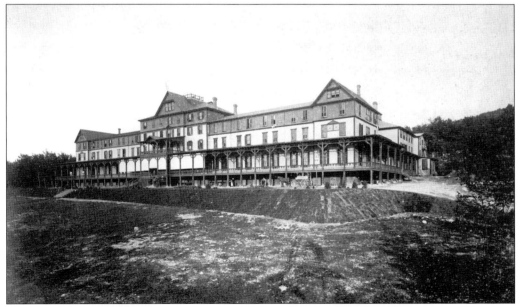

The Blue Mountain House was built in just 83 days at a cost of $225,000. Presidents Woodrow Wilson and Grover Cleveland were among the many famous guests who visited the resort. The Western Maryland Railway ran a daily Blue Mountain Express from Baltimore and stopped at its own Blue Mountain Station. (Courtesy Washington County Historical Society.)

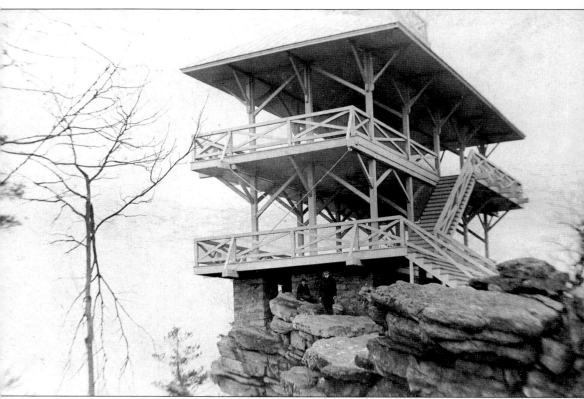

What was once the impressive High Rock Observatory near Pen Mar Park was built in 1878 shortly after the Western Maryland Railway Company opened the park. The three-level wooden structure was located about two miles from the park itself. At 1,400 feet above sea level, the tower provided a panoramic view of the Cumberland Valley. Also known as "The Place of Perpetual Breezes," tourists could hire a horse-drawn carriage for 15¢ to take them from the park to the observatory. Today, only the rock foundations of this popular attraction remain. (Courtesy Washington County Historical Society.)

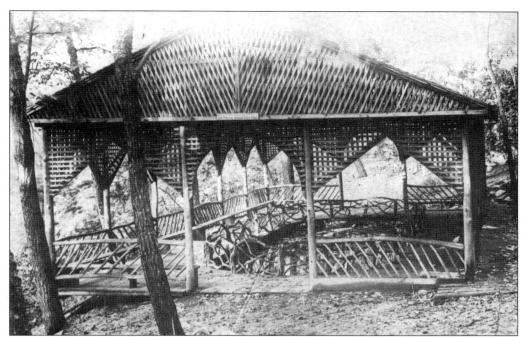

This view of Glen Afton Spring will surely bring back memories to those who remember the old Pen Mar Park. The spring that delivered the crystal clear mountain water was on a lower level than the pavilion, on the opposite side of the railroad tracks from the park. (Courtesy *Maryland Cracker Barrel*.)

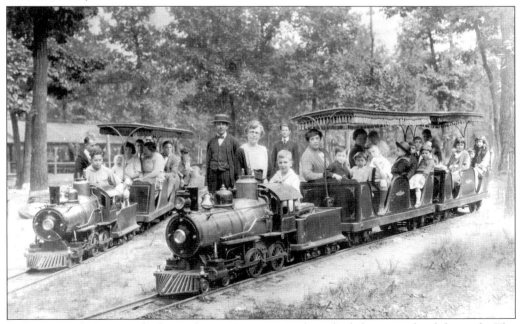

This great old photograph shows the miniature train that plied the grounds of the park. The illusion was complete with the train's own railway station. The fare for two trips around the tracks was only 10¢! (Courtesy *Maryland Cracker Barrel*.)

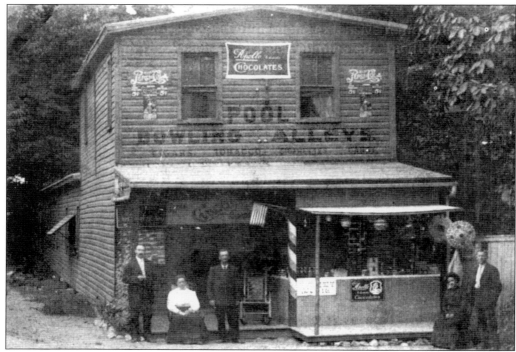

Taken in 1903, this photo shows Crilly's Pool and Bowling Alley Center at Pen Mar Park. It was one of the first concessions at the park and one of the last to close. Harry "Mike" Crilly and his wife are shown on the right of the picture. (Courtesy *Maryland Cracker Barrel.*)

Though the attractions and hotels of days gone by are no longer there, Pen Mar Park was reopened as a county park in 1977, more than 30 years after the original park had closed. Landmarks from the old days are marked with signposts throughout the park. (Courtesy Western Maryland Room, Washington County Free Library.)

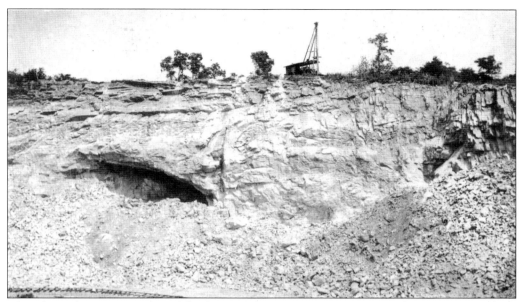

This photo shows a rare view of the famous cave in Cavetown in 1915. This cave, from which the town took its name, was the oldest known cave in Maryland. It was opened to the public and touted as a natural wonder as early as 1823 when people paid 12.5¢ to enter the illuminated cave, which included a number of rooms and ended in a large underground lake. Sadly, the cave disappeared around 1920 as a result of limestone quarrying operations. (Courtesy Western Maryland Room, Washington County Free Library.)

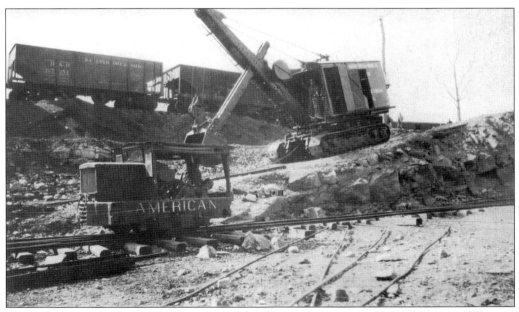

A steam shovel loads B&O train cars at the Cavetown quarry c.1919. (Courtesy Western Maryland Room, Washington County Free Library.)

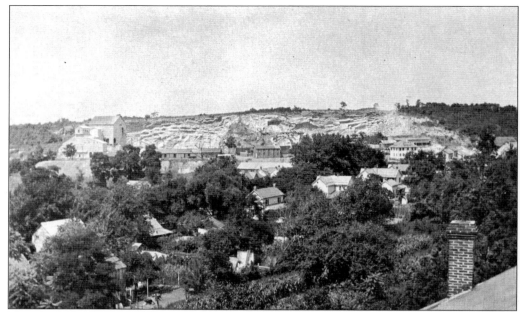

This view of Cavetown was taken in 1920 from the bell tower of the church. The quarry is in the background and the cave used to be situated at the far right of the quarry. (Courtesy *Maryland Cracker Barrel.*)

Taken in the late 1800s, this photo shows the old Cavetown Pike tollgate. The tollgate and tollhouse are long gone, as is the town's namesake cave. (Courtesy *Maryland Cracker Barrel.*)

Five

WILLIAMSPORT AND THE C&O CANAL

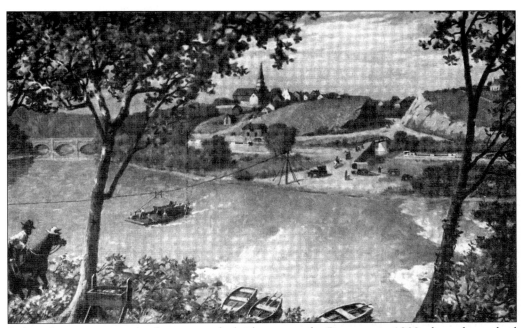

Before the construction and opening of a bridge across the Potomac in 1909, the only method of passage from Williamsport, Maryland to the West Virginia shore was via ferryboat. A canal boat can be seen in the middle of this oil painting as well as an aqueduct on the left. (Courtesy *Maryland Cracker Barrel*.)

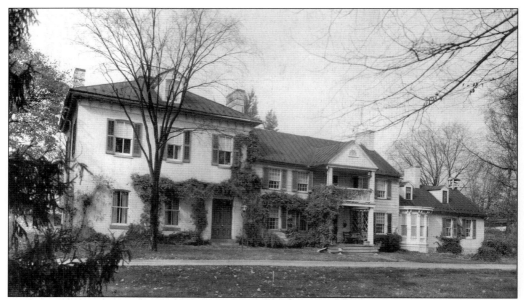

Taken in 1949, this photo shows the Springfield Farm House in Williamsport. One of the oldest homes in the county, the farm was built around 1755. Gen. Otho Holland Williams, a hero from the Revolutionary War and a friend of George Washington, owned the stately farmhouse. Williams's brother, Elie, managed the farm and estate. Elie would go on to become the chief surveyor for the C&O Canal as well as president of the commission to lay out the National Road. (Courtesy Washington County Historical Society.)

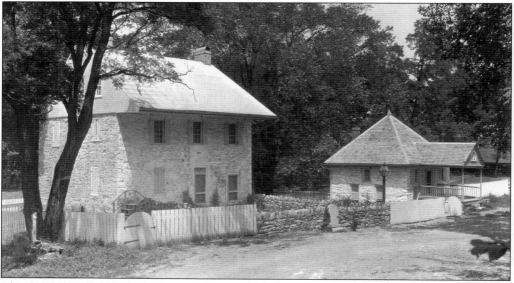

The Springhouse and Still House at Springfield Farm are depicted in this image from 1941. George Washington visited Washington County in October 1790 and, after visiting Hagerstown on October 20th, traveled on to Williamsport the next day to dine at Springfield Farm. Washington was seriously considering locating the capital of the new nation in Williamsport. He also was interested in the Potomac River's navigational possibilities that would later lead to the C&O Canal. (Courtesy Washington County Historical Society.)

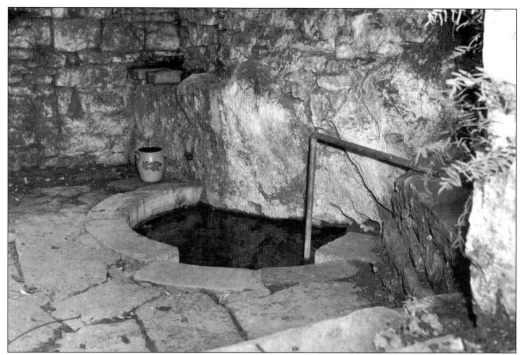

George Washington and General Braddock reportedly drank from this spring at Springfield farm, pictured here in 1949, during a visit to the area. (Courtesy Washington County Historical Society.)

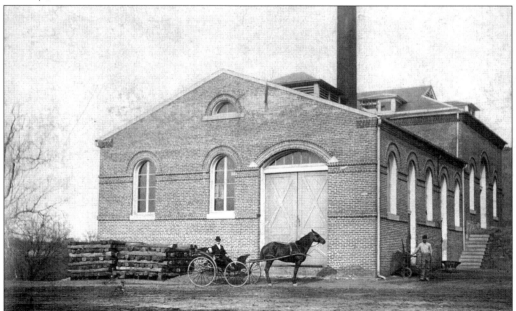

This trolley car repair building is at the C&O Canal Cushwa Basin in Williamsport. Today, the building houses displays during the annual C&O Canal Days held in Williamsport every August. (Courtesy Western Maryland Room, Washington County Free Library.)

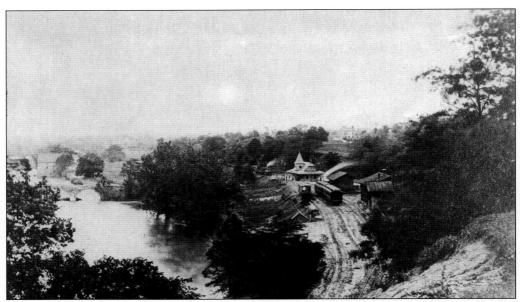

This is an image of the old Williamsport Western Maryland Railroad Station that was taken on June 5, 1889. (Courtesy Washington County Historical Society.)

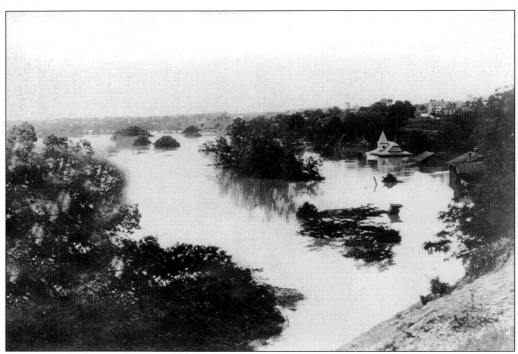

In this photo of the Williamsport railroad station you can see the tracks and buildings under water in one of the numerous floods that have hit Williamsport over the years. (Courtesy Western Maryland Room, Washington County Free Library.)

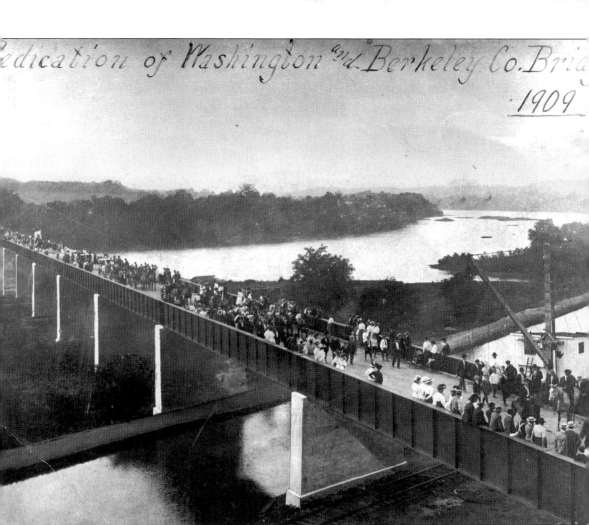

In 1908, determined citizens of Williamsport appealed to the county commissioners to build a bridge across the Potomac from Williamsport to Berkeley County, West Virginia. A "Bridge for the Public," built at a cost of $100,000, was originally designed as a toll bridge, charging 25¢ for a horse-drawn wagon. On April 1, 1958 the toll was removed and has remained toll free ever since. The bridge, which carries the traffic of U.S. Route 11, is said to be the only Potomac River bridge between Washington, D.C. and Cumberland to have survived the devastating flood of 1936. The above photo is from the dedication of the bridge, which took place on August 10, 1909. The Route 11 Bridge underwent rebuilding in 1978–1979. (Courtesy Western Maryland Room, Washington County Free Library.)

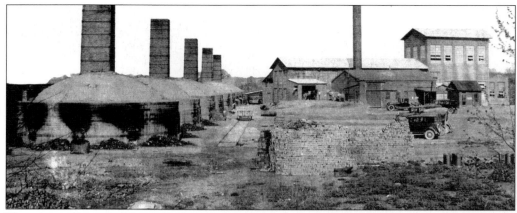

This photo shows the Victor Cushwa & Sons brick making plant in Williamsport as it appeared in 1924. Victor Cushwa purchased the Conococheague Brick and Earthenware Company in 1897 to supplement his coal business along the banks of the C&O Canal. Bricks from the company have been used in historic restorations in places such as Williamsburg, Virginia and Independence Square in Philadelphia, Pennsylvania. (Courtesy *Maryland Cracker Barrel*.)

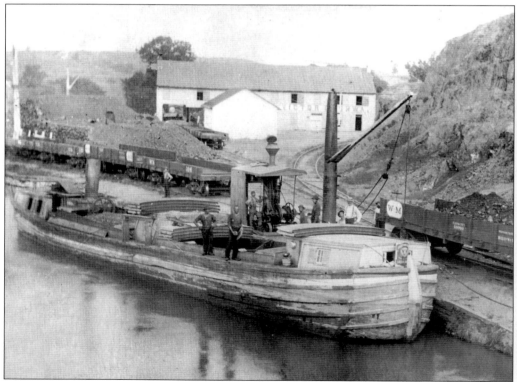

Taken in the late 1800s, this photo shows the C&O Canal Cushwa Wharf in Williamsport. The Victor Cushwa Brick Factory has sold bricks throughout the United States, including many of the bricks needed during the restoration of historic Williamsburg, Virginia. (Courtesy Washington County Historical Society.)

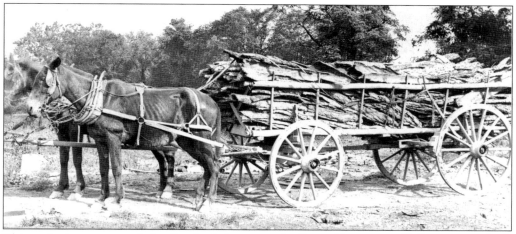

This mule-drawn wagon is hauling bark for use at the Byron Tannery in Williamsport, which was erected in 1897. Still in business today as the Garden State Tannery, the company turns hides into finished leather for use in the automotive industry. The Byrons owned a large stately home on North Potomac Street in Hagerstown. It stands in tribute to the prosperity the area enjoyed. (Courtesy Washington County Historical Society.)

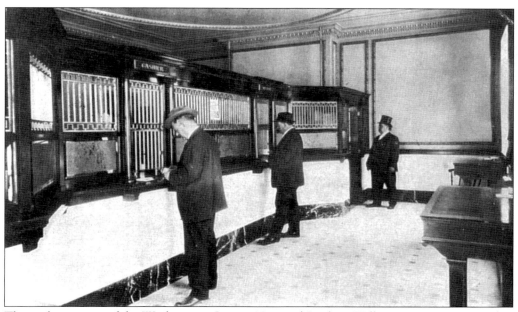

This is the interior of the Washington County National Bank in Williamsport as it appeared in 1919. Note the man in the top hat as well as the barred windows for the tellers. (Courtesy Western Maryland Room, Washington County Free Library.)

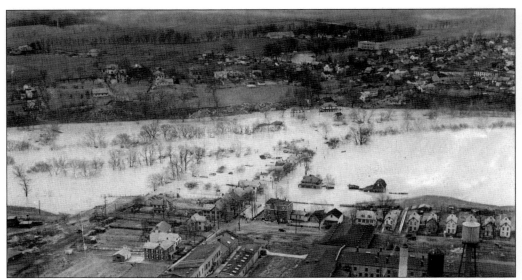

Taken on March 19, 1936 with a Fairchild aerial camera, this photo shows Williamsport and Conomac Park in the aftermath of the flood of March 18, 1936. (Courtesy Western Maryland Room, Washington County Free Library.)

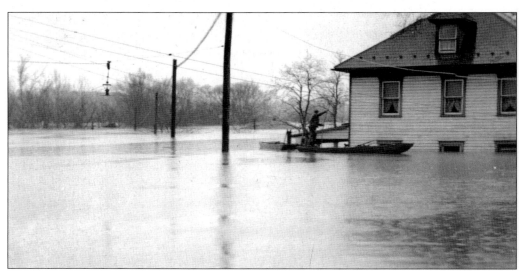

This photo of Williamsport after the flood shows that the water level actually climbed past the first floor of many buildings and homes. (Courtesy Western Maryland Room, Washington County Free Library.)

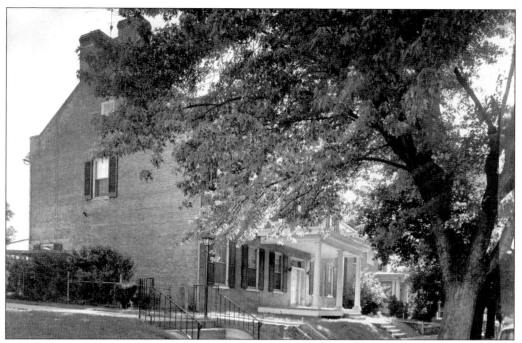

Located at 26 East Salisbury Street in Williamsport is the Steffey House, built in 1804. The brick house was originally designed as a bank and, in the custom of the day, a residence for the banker's family. (Courtesy Western Maryland Room, Washington County Free Library.)

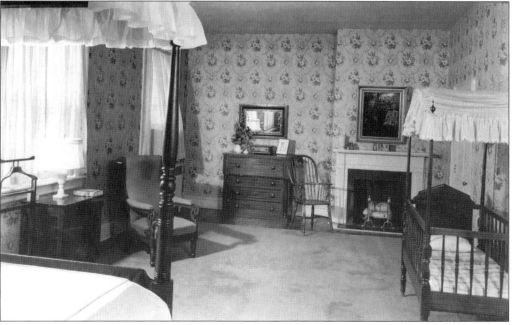

This interior view of the Steffey House shows the master bedroom, just one of five bedrooms, three with fireplaces. Note some of the period furnishings such as the infant's crib and four-post master bed. (Courtesy Western Maryland Room, Washington County Free Library.)

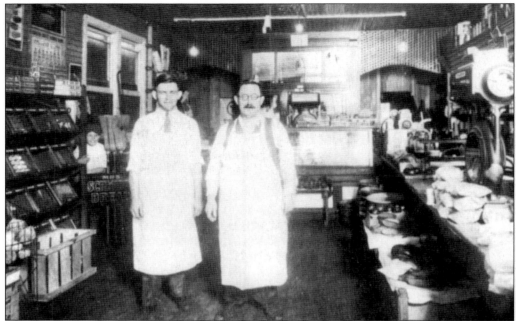

Harsh's Meat Market was originally located at 5 East Potomac Street in Williamsport and later moved to Artizan Street. Store founder Albert S. Harsh stands with his son Martin D. Harsh Sr. inside the original store in 1927. (Courtesy *Maryland Cracker Barrel*.)

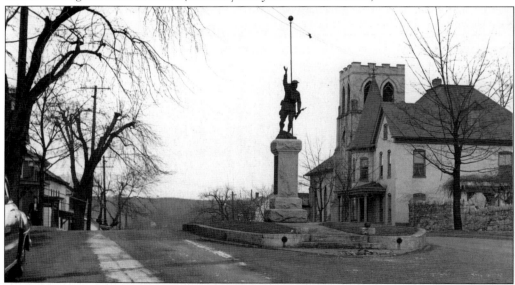

This photo shows the World War I Memorial in Williamsport in front of the Lutheran Church. To the left of the memorial across the Potomac "Maidstone on the Potomac" in West Virginia can be seen. Lord Fairfax set the land for Maidstone apart in the 1740s for a manor adjacent to the Evan Watkins' ferry that ran across the Potomac to Conococheague. Located on part of the land is Maidstone Manor,which was built in 1847 and was the childhood home of William Robinson Leigh, an artist well known for his depictions of the Old West. (Courtesy Washington County Historical Society.)

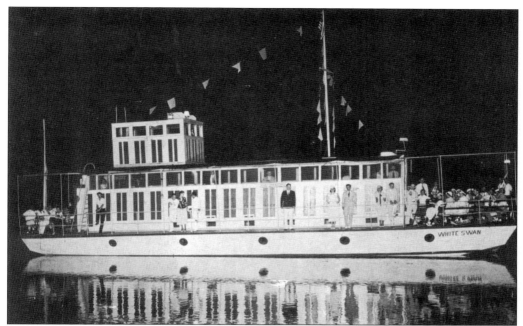

From 1932 to 1936 the *White Swan* cruise boat ran along the Potomac River between Dam#4 and Falling Waters, West Virginia. It cost $6,000 to construct and carried between 3,000 and 6,000 passengers a year. Accommodating 125 people per voyage, the boat had a 35-foot-long dining room and a 40-foot-long dance floor. The boat was completely destroyed in the 1936 flood. (Courtesy *Maryland Cracker Barrel*.)

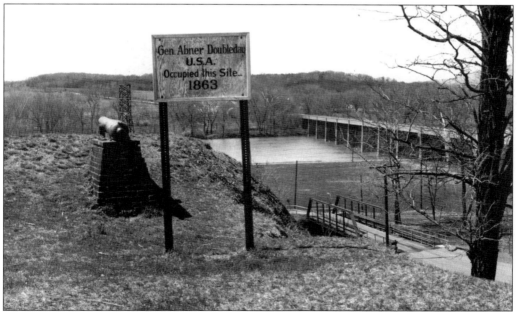

This photo shows Doubleday Hill in Williamsport. It was occupied by Gen. Abner Doubleday and the first shots across the Potomac during the Civil War were fired from here. (Courtesy Western Maryland Room, Washington County Free Library.)

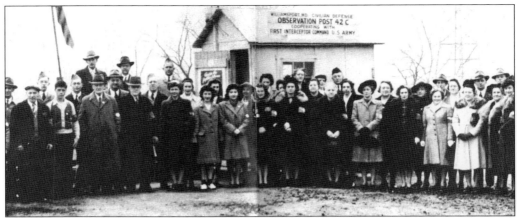

This is a group of World War II airplane spotters from Williamsport in late 1942. An important part of civilian defense on the home front, airplane spotters scanned the skies up and down the coast for any possible enemy planes. The observation post would have included posters depicting the silhouettes of various kinds of aircraft and communications radio (Courtesy *Maryland Cracker Barrel.*)

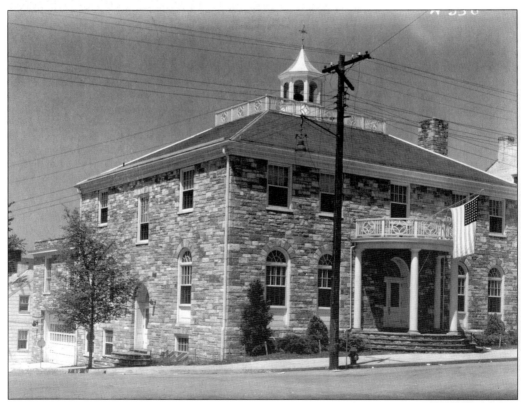

The stately Williamsport Town Hall stands on Conococheague Street. This building, as well as the library and the community park building were constructed during the Depression years as part of President Roosevelt's Public Works Administration (PWA) and the Works Progress Administration (WPA). (Courtesy Washington County Historical Society.)

Here we see the barn at Springfield Farm. Build around 1875, the barn today has been renovated to hold the Town of Williamsport Museum. (Courtesy *Maryland Cracker Barrel.*)

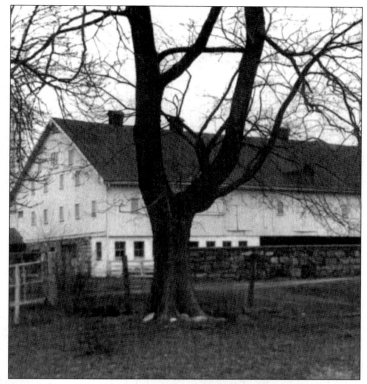

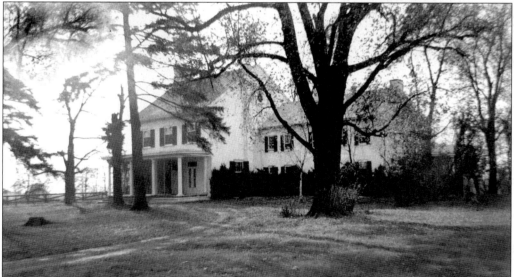

Taken in November 1956, this photograph depicts the Tammany Manor (also known as Mount Tammany), which is located not far from Williamsport. Built after the Revolutionary War by Matthew Van Lear, the home was named Tammany after the chief of the Delaware Indians. Related by marriage to the Van Lears, William Henry Harrison, the ninth President of the United States, dined at Tammany on his way to Washington, D.C. to be inaugurated in 1841. (Courtesy Washington County Historical Society.)

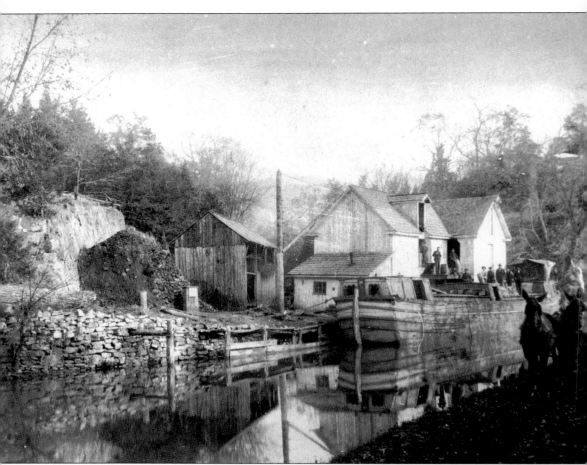

This photo, c.1890, shows Abe Roth's warehouse along the C&O Canal in Pinesburg, Maryland. Take special note of the far right of the photo where two mules are engaged in their task of pulling the canal barge. The canal mule could pull twice the load of a comparable size horse and worked two 8-hour shifts every 24 hours. During rest periods, the mules were stabled in stalls at the forward end of the barge. (Courtesy Washington County Historical Society.)

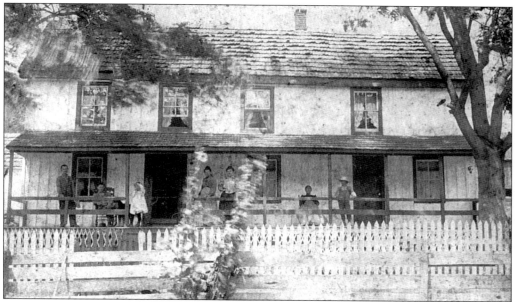

Lift Lock 56, the last lock of the C&O Canal in Washington County, was located in the small town of Pearre between Sidling Hill and Tonoloway Ridge. This *c.1890* photo shows lockkeeper Thomas F. Donegan with some of his family in front of the house he built. (Courtesy *Maryland Cracker Barrel.*)

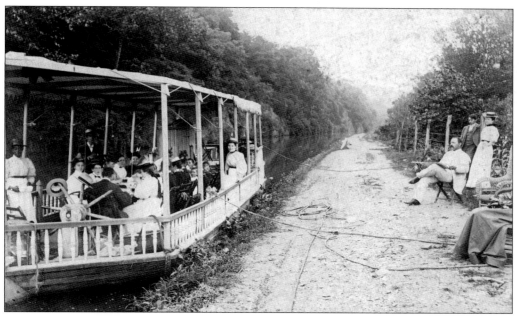

Here is a boating party out for a day of recreation along the C&O Canal during the summer of 1897. The canal runs 184.5 miles along the Potomac River beginning in Georgetown, D.C. and flowing westward to Cumberland, Maryland. Excursions such as these were popular diversions during the canal's heyday. (Courtesy Washington County Historical Society.)

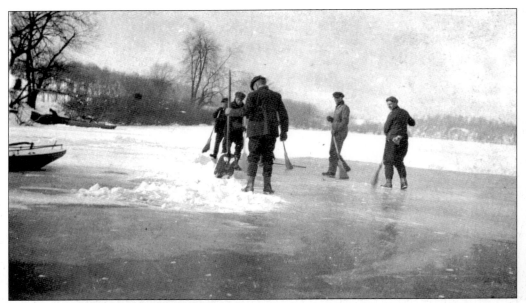

These men clear the ice on the C&O Canal at Dam #4 in 1917. Four of the six dams built on the canal to supply it with water from the Potomac River are in Washington County. Dam #4 is not far from the area known as Big Slackwater. Big Slackwater and Little Slackwater are areas where the river was deep enough to carry the canal boats. The boats entered the river, traveled along for a distance and then re-entered the canal. (Courtesy Western Maryland Room, Washington County Free Library.)

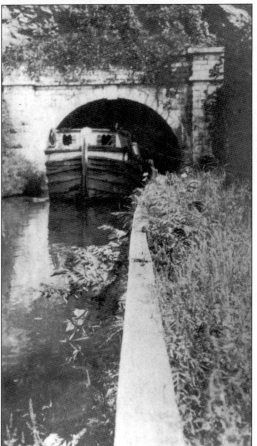

Taken in 1918, this photo shows a canal boat coming through one of the many tunnels along the C&O Canal. (Courtesy Washington County Historical Society.)

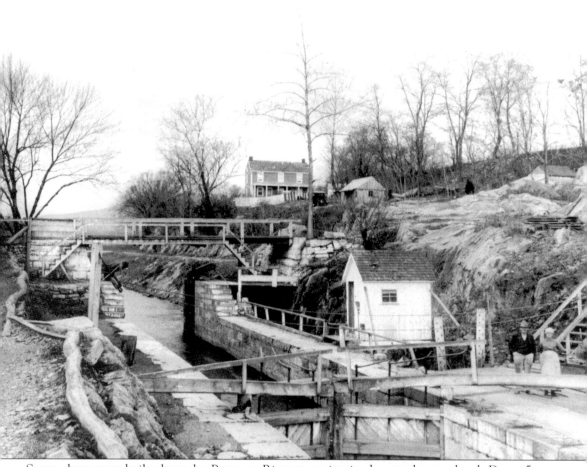

Seven dams were built along the Potomac River to maintain the canal water level. Dam #5, shown here with its guard lock, was responsible for the water level on a 22.3-mile stretch of the canal. During the years of the Civil War, the C&O Canal was responsible for carrying coal from Cumberland and flour, wheat, and corn from nearby farms to supply Union troops and the nation's capital. Stonewall Jackson planned to cut off this supply line and tried twice in December 1861 to blow up the dam. Union forces held him back, repaired the damages, and kept the boats moving. (Courtesy Washington County Historical Society.)

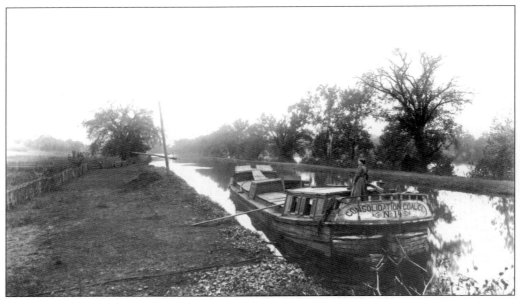

This early photo shows Coal Barge #14 stopped along the C&O Canal. Originally planned to extend all the way from Georgetown to the Ohio River near Pittsburgh, Pennsylvania, the canal ended up being half that distance and only reached as far as Cumberland. Chief cargoes included coal, grain, cement, lumber, bricks, and produce. (Courtesy Washington County Historical Society.)

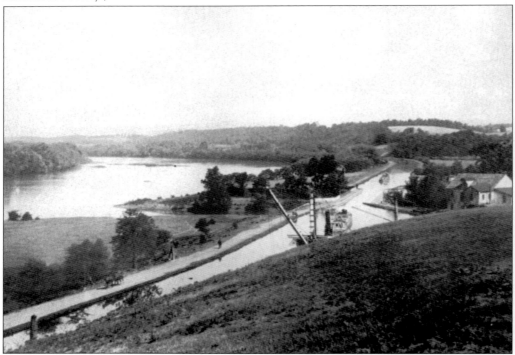

Taken prior to 1906, this Williamsport view shows both the C&O Canal and the Potomac River. (Courtesy Western Maryland Room Washington County Free Library.)

A few miles from Interstate 70, not far from Big Spring and Clear Spring, lies the area known as Four Locks. During the heyday of the C&O Canal, this area, pictured here in the early 1900s, was a thriving village of homes and businesses tied to the commerce of the canal. (Courtesy Western Maryland Room Washington County Free Library.)

This flume at Lock 47 at Four Locks was situated next to a dry dock used for canal boat repairs. The canal required the construction of the four locks, Locks 47 through 50, on the short one-mile stretch because of a 32-foot change in elevation. Just below Four Locks was the area known as Two Locks, where Locks 45 and 46 were built within the space of one-tenth of a mile. (Courtesy Western Maryland Room, Washington County Free Library.)

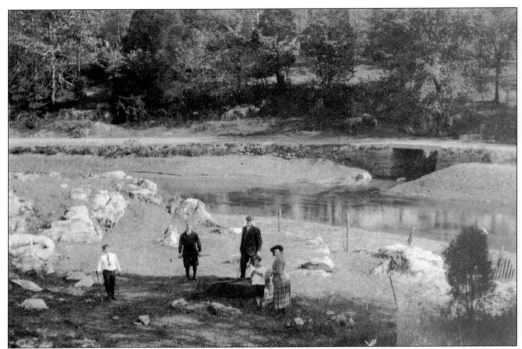

When the canal closed in 1924, residents of Four Locks whose families had lived there for generations began to move away because their livelihood disappeared. The post office and school closed, and houses and stores were deserted. This family is pictured by the canal in the early 1900s, just a few years before it would close for good. (Courtesy Western Maryland Room Washington County Free Library.)

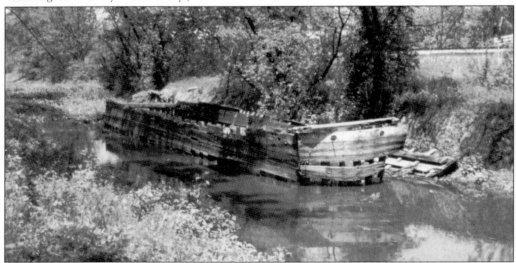

Taken in 1958, this photo shows the sad remains of Boat #57 on the C&O Canal in Hancock. The government acquired the canal in 1938, but it was not declared a National Monument until 1961. Created as a National Historic Park in 1971, today it is a popular spot for hiking, biking, camping, boating, fishing and many other recreational activities. (Courtesy Western Maryland Room, Washington County Free Library.)

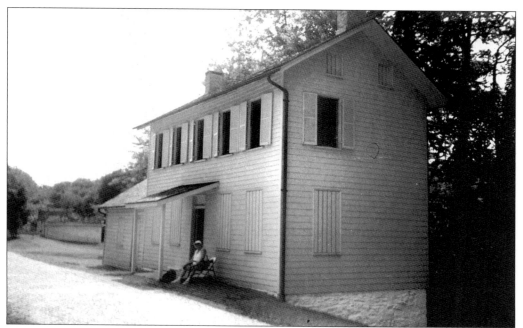

This photo shows the now unused Lock 44 lockkeeper's house in Williamsport. The interior of the building has marks on the stairs going to the second level indicating the height water had reached during various floods. (Courtesy Mary H. Rubin.)

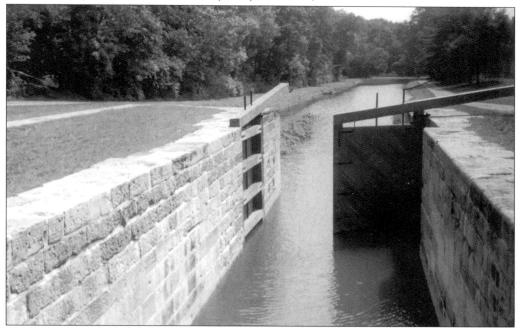

This photo shows the partially open Lock 44, no longer in use, on the C&O Canal. The other side of the lock gates would also have been closed during the raising or lowering of a boat. It took about 10 minutes for a boat to "lock through." The locks are 100 feet long, 15 feet wide, and 16 feet deep. (Courtesy Mary H. Rubin.)

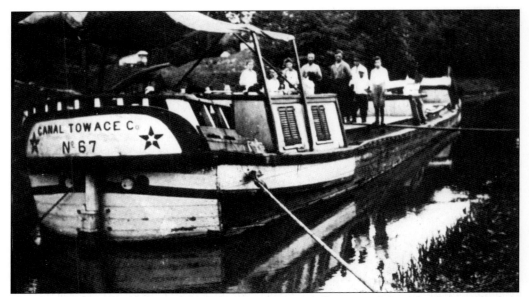

This family is on Canal Boat #67 of The Canal Towage Company. Many families made their homes on the boats that plied the C&O Canal. The operation was a family affair with even young children taking part by caring for the mules that pulled the boats. Quarters below deck on the boat included family accommodations and special stalls in which the weary mules could rest between shifts. (Courtesy Western Maryland Room, Washington County Free Library.)

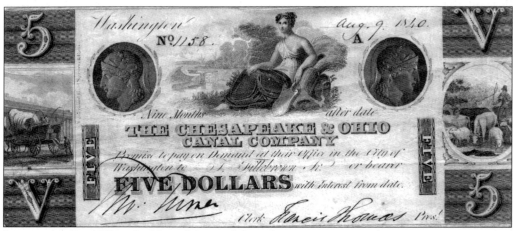

Prior to the Civil War, the United States did not have a true national currency—paper money was issued by state banks. Some of these banks helped finance canal construction. While intricately engraved, the money was easy to counterfeit. This C&O Canal banknote, dated August 9, 1840, was good for "Five Dollars with interest." Note the intricate artwork adorning the note. (Courtesy Western Maryland Room, Washington County Free Library.)

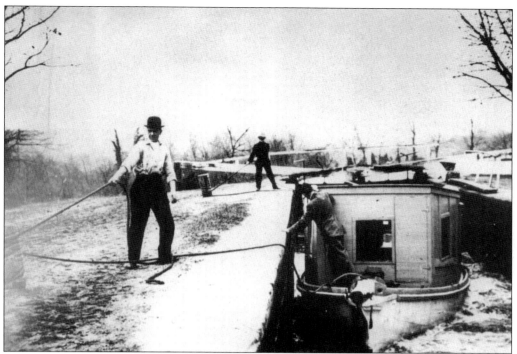

Here we see a paymaster's boat moving through a lock along the C&O Canal. (Courtesy Western Maryland Room, Washington County Free Library.)

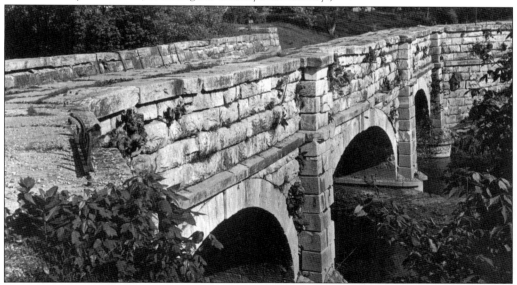

Built in 1834, the Antietam Aqueduct was one of two large bridges in Washington County built to carry boat traffic over another waterway. Irish workers died in great numbers during a tragic outbreak of cholera during the construction of the aqueduct that would eventually carry the C&O Canal over Antietam Creek near Antietam Furnace. The second of these large aqueducts is in Williamsport and carried the canal over Conococheague Creek. (Courtesy Washington County Historical Society.)

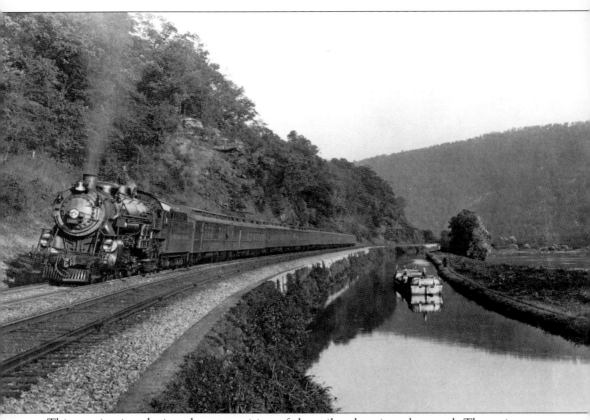

This scenic view depicts the competition of the railroad against the canal. The train steams alongside the C&O Canal as a canal barge progresses at a much slower rate. The coming of the railroad and its promise of quicker, easier delivery of goods spelled the beginning of the end for the canal trade and the canal ceased being used in 1924. Taken in 1923, this photo shows the Canal Towage #49 bound for Washington, D.C. with 120 tons of coal. The train was Baltimore & Ohio's *Capitol Limited* on its way west to Cumberland. The boat's captain was George Bowers and the mule driver was Lloyd Lemen. Standing on deck is Heaver Eversole. All three men were from Williamsport, Maryland. (Courtesy Washington County Historical Society.)

Six

BOONSBORO AND THE NATIONAL ROAD

Taken in 1939, this photo shows Main Street in Boonsboro, Maryland stacked high with berry crates illustrating that the town was the hub of the county's "berry belt," which reached from Mapleville south to Rohrersville. Berry production was one of the area's main industries during the 1920s, 1930s and 1940s. (Courtesy *Maryland Cracker Barrel*.)

Boonsboro Days, an annual event in Boonsboro, Maryland, is a gala that includes craftsmen demonstrating trades and crafts of years gone by. This photo was taken downtown during the event on the Fourth of July in 1919. (Courtesy *Maryland Cracker Barrel*.)

John Brining opened his cabinetmaker's shop in Boonsboro in 1837. He constructed not only fine furniture but also custom coffins. William Bast joined the firm in the latter part of the 19th century and eventually became the owner, as stated on the store sign in the 1919 photo above. Today, although they no longer build their own pieces, Bast Furniture is still known for their quality furniture. (Courtesy *Maryland Cracker Barrel*.)

Here we see an old view of the Washington Monument in Boonsboro. This first monument in the country to honor the first president of the United States was built within 24 hours by the citizens of Boonsboro as part of a July 4th celebration in 1827. The structure was built of native blue granite found on the site and was constructed of dry stone without mortar. Unfortunately, the mortarless construction allowed weather and vandalism to reduce the monument to a pile of rocks. The Boonsboro Odd Fellows Lodge restored the monument in 1882 and added a road up to the site. (Courtesy Washington County Historical Society.)

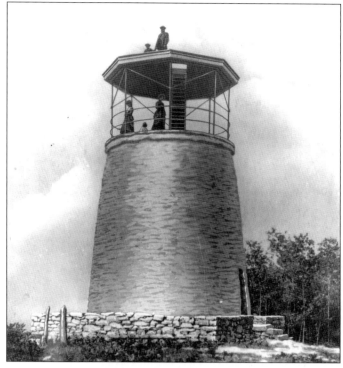

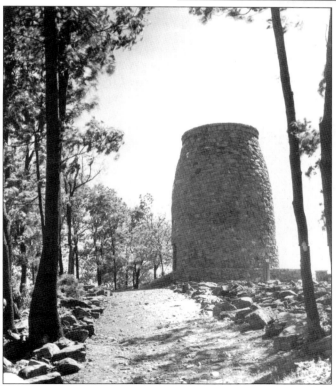

Here we see the Washington Monument as it appears today. The monument had fallen into disrepair again after the restoration attempt in 1882, and in 1924 the Washington County Historical Society deeded the site to the State of Maryland to develop a state park. The Civilian Conservation Corps reconstructed the monument during the Depression and it was formally rededicated on July 4, 1936. The monument lies directly on the Appalachian Trail and the three states of Maryland, Virginia, and West Virginia are all visible from the tower's summit. (Courtesy Washington County Historical Society.)

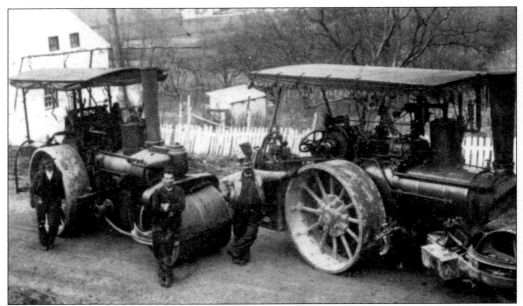

Taken c.1911, this photograph shows workers repairing the Old National Pike east of Boonsboro near the top of South Mountain. Just look at those old machines! (Courtesy *Maryland Cracker Barrel*.)

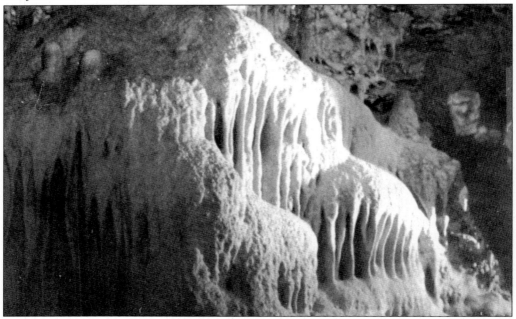

Maryland's only natural underground caverns that are open to the public are located just south of Boonsboro. Now called the Crystal Grottoes, they were discovered quite by accident on September 18, 1920 by a state roads crew quarrying limestone. The caverns opened to the public on April 2, 1922. The Crystal Grottoes grow at the slow rate of one cubic inch every 100 to 150 years. The cavern contains more formations per square foot than any other known cavern. (Courtesy *Maryland Cracker Barrel*.)

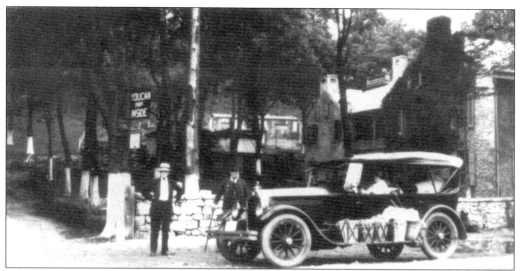

The Old South Mountain Inn dates back to around 1750 when it was owned by Robert Turner and therefore is one of the oldest buildings in the county. It has always been an inn or tavern except for about 50 years when it was a private residence. Situated at Turner's Gap on what is now Alternate Route 40, the inn is a popular location for fine dining throughout the region. This photo of a 1927 Buick Touring car parked in front of the inn was taken in August 1928. The inn is on the Washington-Frederick County line on the Old National Pike and motorists often came from Washington, D.C. for a scenic drive and to purchase local produce—note the baskets full of fresh items on the running board. (Courtesy *Maryland Cracker Barrel*.)

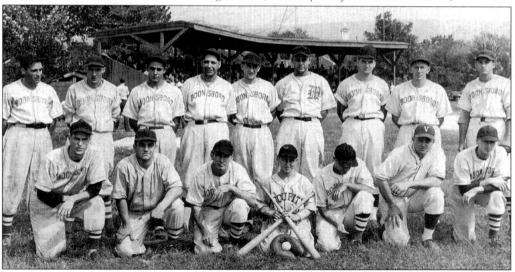

This is a 1947 photo of the Boonsboro team who competed in the Washington County League. Many people from Washington County aspired to be in the major league, but their careers were interrupted by World War II. Taken in Boonsboro's Shafer Park, this photo includes, from left to right, the following: (front row) Bobby Whitt, Drake Dofflemyer, Harry Schlotterbeck, two unidentified people, Joe Hartle, and unidentified; (back row) Tommy Knode, two unidentified people, Snub Rowe, Paul Norris, Ed Barr, unidentified, Dick Griffith, and Dick Guyton. (Courtesy *Maryland Cracker Barrel*.)

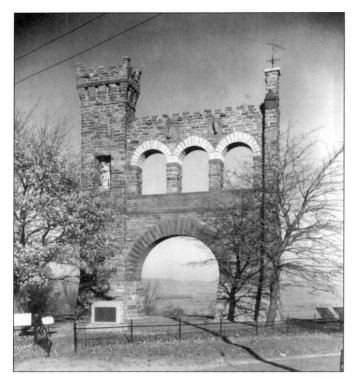

Constructed in 1896, the Civil War Correspondents Monument stands on the top of South Mountain near Boonsboro. Built by George Alfred Townsend, the arch is a tribute to all the writers, artists, and photographers who reported the Civil War. Townsend signed his writing with the pen name "GATH" and when the State of Maryland bought the land around the arch in 1959, the park they created was named Gathland State Park. While the arch is actually located in Frederick County, the park straddles both Washington and Frederick Counties. (Courtesy Washington County Historical Society.)

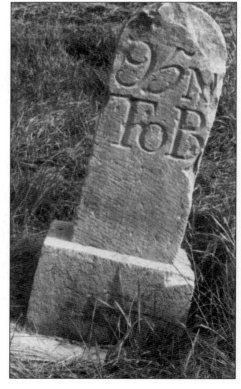

The National Pike was once the busiest road in America. The road was peppered with milestone markers all along the route. Many still exist, though the engravings have become well worn over the years. Here is a Washington County marker that is still easy to read and tells travelers it is 95 miles to Baltimore (95 M to B). Other markers of varying height can also be found along Alternate Route 40 between Boonsboro and Funkstown as well as other sites . (Courtesy *Maryland Cracker Barrel*.)

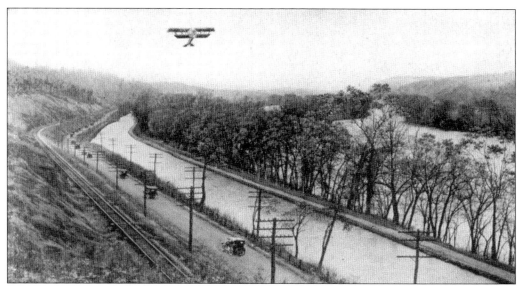

Here is an old view of the National Highway c.1920 on a stretch of road along the C&O Canal between Hancock and Hagerstown. Note the long line of cars stretching down the road as well as the biplane in the sky. (Courtesy Western Maryland Room, Washington County Free Library.)

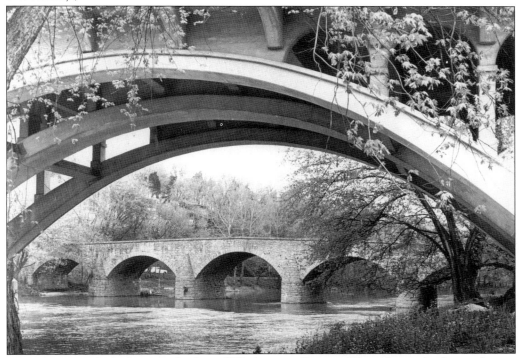

Army engineers built the stone bridges of Washington County. The oldest is the five-arch span of Wilson's Bridge over the Conococheague Creek west of Hagerstown. Built in 1819, it was part of the westward expansion of the National Road toward Ohio. (Courtesy Washington County Historical Society.)

Here is one of the National Road tollhouses in Washington County. Note the large toll bar gate on the far right anchored on the ground and shown in its raised position to allow the travelers to pass through. (Courtesy Western Maryland Room, Washington County Free Library.)

NOTICE
TO ALL WHOM IT MAY CONCERN.
ON AND AFTER
Novemb'r 1, 1864.
THE FOLLOWING
RATES OF TOLLS
WILL BE CHARGED ON THE
BALTIMORE & FREDERICK AND BOONSBORO
TURNPIKE ROADS
FOR A TEN MILE GATE. CENTS

						CENTS
For every score of Sheep or Hogs,				-		20
For " " Cattle,			- - - -			40
For every Horse & Rider, or led Horse,						10
For every Wagon with 1 Horse, Narrow Wheels,						20
" " "	2		"	"		40
" " "	3		"	"		60
" " "	4		"	"		80
" " "	5		"	"		1.00
" " "	6		"	"		1.20
" " Coach, with four Horses,						60

One-half of the above Rates for a Broad-Tread Wagon. All Wagons whose wheels does not measure full four inches will be charged as Narrow-Tread from the above date.

By order of the Presidents, Managers and Companies of the above mentioned Roads.
October 8, 1864.

This notice contains details of the categories and fees charged for passage along the National Pike. This rate schedule gives us an idea of the wide variety of traffic that traversed the road. (Courtesy Western Maryland Room, Washington County Free Library.)

Seven
OTHER COUNTY
LOCALES

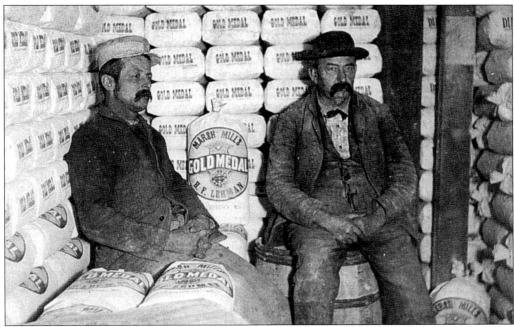

Here we see William Barton Lehman and Benjamin Stewart seated inside Lehman's Mill. Earlier known as Marsh Mills, the stone mill was built around 1760 and existed until Henry Lehman replaced it with a brick structure in 1869. The 1860 manufacturing census reported that the mill produced 4,000 bushels of flour valued at $24,000. The coming of the Western Maryland Railroad to this northern part of Washington County was important to the growth of the surrounding Paramount and Reid areas. (Courtesy *Maryland Cracker Barrel*.)

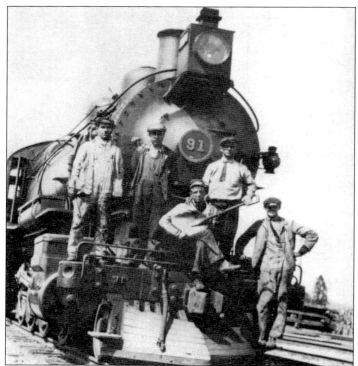

This 1905 photo shows a freight crew at Maugansville, Maryland. Abraham Maugans and his wife Elizabeth purchased and settled on 880 acres of land in Washington County in 1827. Those acres spread in time to become Maugan's Towne, later Maugansville. (Courtesy *Maryland Cracker Barrel.*)

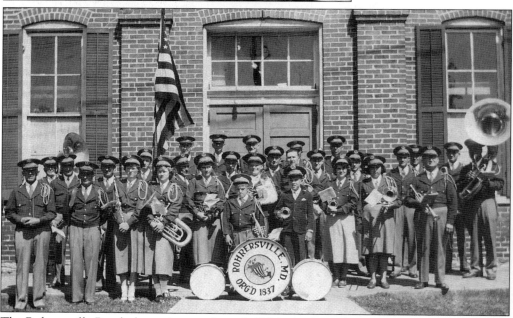

The Rohrersville Band, shown here on June 6, 1954, was formed over 100 years earlier in 1837 when it was organized by G. Washington McCoy as McCoy's Band. The name was changed to Rohrersville Band in 1916 and is the oldest town band in Maryland. The town of Rohrersville, Maryland is situated in the southern part of the county at the base of Elk Ridge Mountain in Pleasant Valley. (Courtesy *Maryland Cracker Barrel.*)

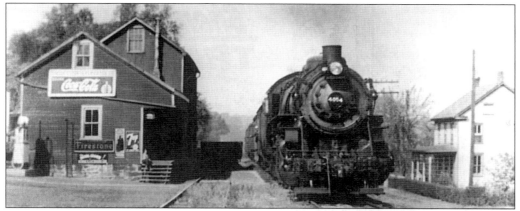

Here we see the Rohrersville Station at Trego in Washington County. Many of the berries grown in the county's "berry belt" were shipped from Trego. In 1926, 26,500 crates of berries were shipped from the county, helping rank Maryland as second in the nation in the production of berries, closely following New York State. (Courtesy *Maryland Cracker Barrel*.)

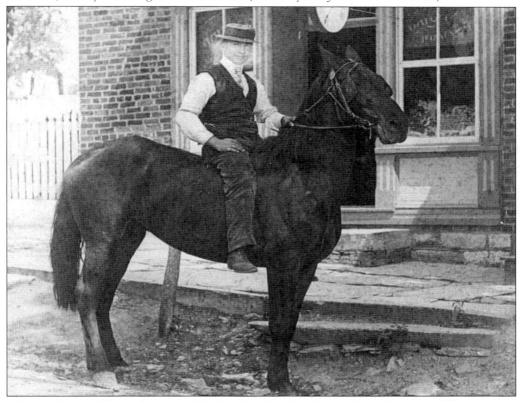

John and Samuel Keedy developed Keedysville, Maryland just eight miles south of Hagerstown. Originally settled in the 1700s, the village grew up around the gristmill that Jacob Hess built in 1783 and was called Centreville since it was situated at the center point between Sharpsburg and Boonsboro. The name of the town was changed to Keedysville when the town's post office was established. This man on horseback in the photograph above is outside E.E. Wyands clock repair shop in Keedysville. (Courtesy Washington County Historical Society.)

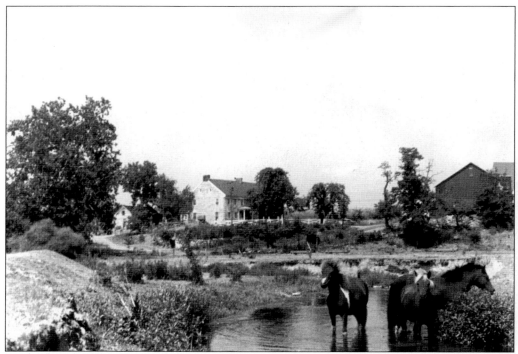

Taken c.1965, this photo shows Felfoot Farm in Keedysville. The barn at the farm is dated c.1750. The nearby Felfoot Bridge over Little Antietam at Dog Street Road may be one of the earliest bridges in the county. (Courtesy Washington County Historical Society.)

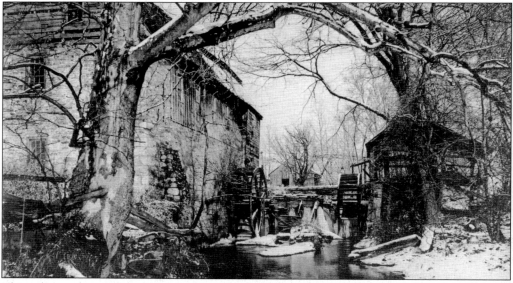

This photo shows the exterior of the Orndorff Mill located between Sharpsburg and Keedysville. Washington County was once home to many mills, cutting lumber and grounding grain. Eleven millstones from several county mills have been preserved in Hagerstown's City Park where they are embedded into the sidewalk at Millstone Circle. (Courtesy Washington County Historical Society.)

Chewsville had its beginnings in 1736 on the Chew family farm. Maryland governor Samuel Ogle was traveling through the area and spent a night with the family. That same evening, twin boys were born to the Chews. In honor of the birth, the governor deeded 5,000 acres of land to the Chews and the community that developed in the area was named for the family. These are Chewsville Elementary School students in 1912. (Courtesy *Maryland Cracker Barrel.*)

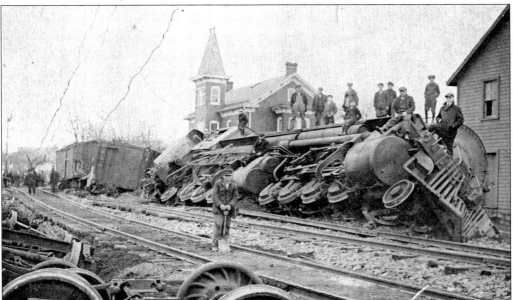

Engine 913 wrecked in May 1917 in Chewsville. The engine seemed destined for destruction because it later caught fire in Baltimore, lost several cars in Hagerstown, and collided with another train in Williamsport. (Courtesy *Maryland Cracker Barrel.*)

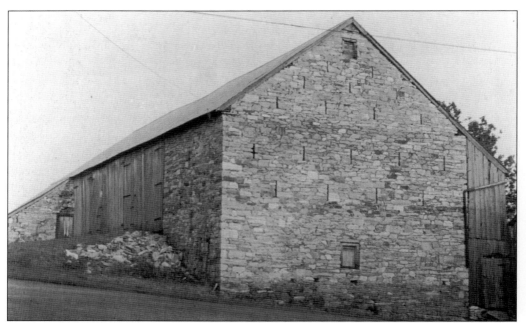

This June 1965 photo of a stone barn near Chewsville is illustrative of the kind of barns that can be found throughout Washington County. Many date back to the 1700s and are a tribute to the building skills of those early settlers. (Courtesy Washington County Historical Society.)

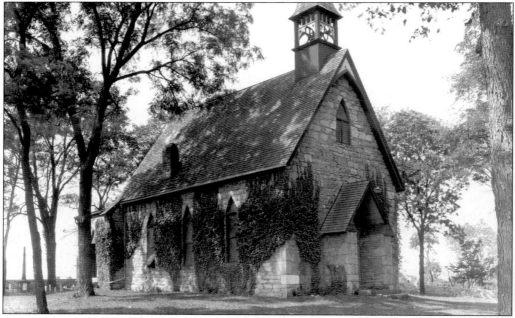

The cornerstone of St. Mark's Episcopal Church at Lappans Crossroads was laid in April 1849. The picturesque church has a rich history and is listed on the National Register of Historic Places. During the Civil War, the Battle of Antietam was fought six miles from the church, and the wounded were brought here for treatment. As a result of damage sustained during the battle, the church was closed for several months. (Courtesy Washington County Historical Society.)

The village of Beaver Creek is just east of Hagerstown. It is situated on the banks of Beaver Creek, which is a tributary of Antietam Creek. The Beaver Creek School in this photo was used as a public school from 1907 to 1961. The two-room building now houses the Beaver Creek School Museum. (Courtesy Washington County Historical Society.)

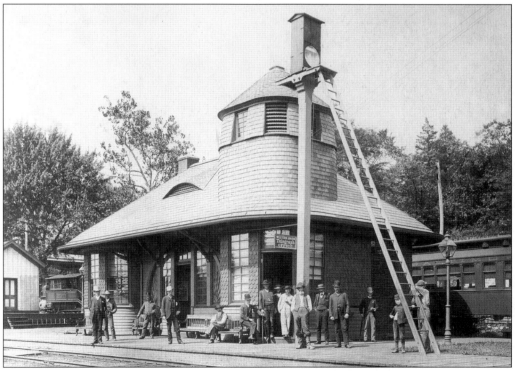

Here we see the old Weverton, Maryland train station with its telegraph office. Note the men dressed for travel in their elegant suits and hats standing with their long umbrellas or walking sticks. (Courtesy Washington County Historical Society.)

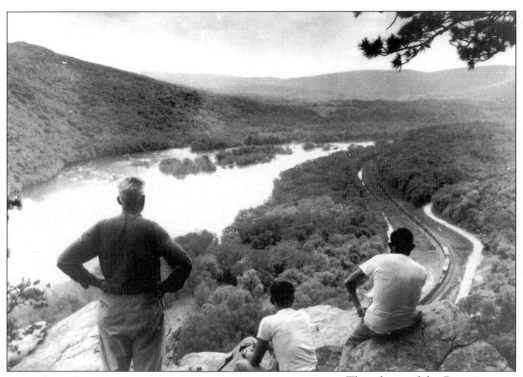

This photo of the Potomac was taken c.1950 from Weverton Heights. Note the canal and the train moving along the right. (Courtesy Western Maryland Room, Washington County Free Library.)

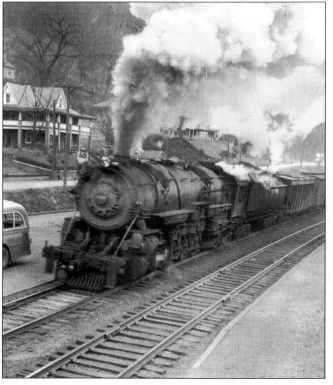

This 1940 photo, taken from the top of an empty boxcar, shows a B&O "Hotshot" freight train traveling about 50 miles per hour through Weverton. Named a "hotshot" because of the priority cargo it carried, such as perishable food goods, the train stopped en route only to change crews. (Courtesy Western Maryland Room, Washington County Free Library.)

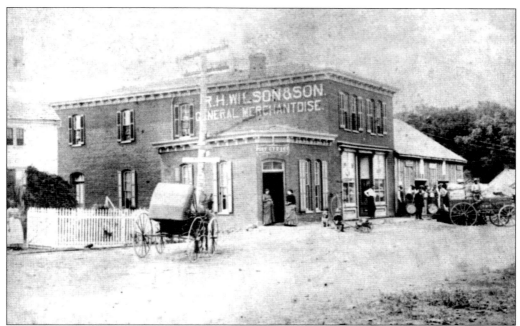

Rufus Hillery Wilson opened his country general store on a hilltop overlooking Conococheague Creek in 1847. A new building was completed just after he died in 1882 when the store was taken over by his son John H. Wilson. The new building was in use until the store closed in 1975. This photo shows the store shortly before the turn of the 20th century. Note the post office at the side of the store as well as the bicycle propped out front. (Courtesy *Maryland Cracker Barrel*.)

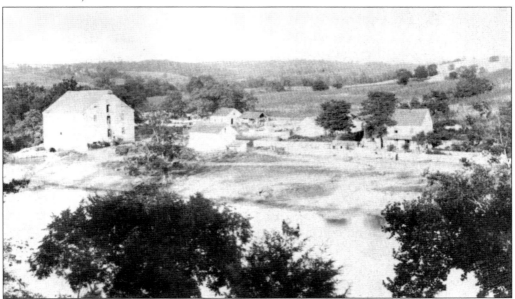

This view is from Wilson's Store looking down on Conococheague Creek. Huyett's Mill is on the left. Today, Wilson's General Store has been restored and is once again in operation. (Courtesy *Maryland Cracker Barrel*.)

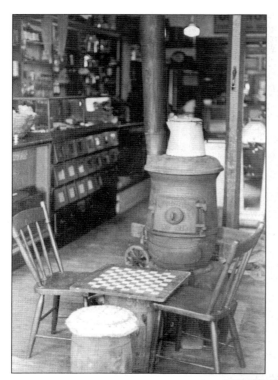

This interior photo of the now restored and reopened Wilson's General Store brings back a touch of the past. Old-fashioned candies as well as other "old time" items are available for sale in this piece of restored history. (Courtesy *Maryland Cracker Barrel.*)

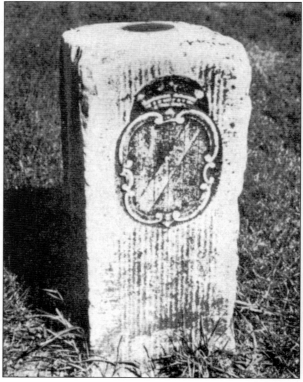

Washington County shares the Maryland state border with Pennsylvania and thus makes up part of the famed Mason-Dixon Line. Shown in the photo is one of the Mason-Dixon Line "Crown Stones." These stones bear the coats of arms of William Penn on the Pennsylvania side and Lord Baltimore on the Maryland side and they were placed at every fifth stone interval along the line. (Courtesy *Maryland Cracker Barrel.*)

This schedule from a promotional brochure advertises the E.V. Hull Motor Bus Line that once operated in the county in the early 1900s. Hull's sold out when the Blue Ridge Line was formed by Potomac Edison. The Blue Ridge Line later sold out to Greyhound in the mid-1950s. (Courtesy *Maryland Cracker Barrel*.)

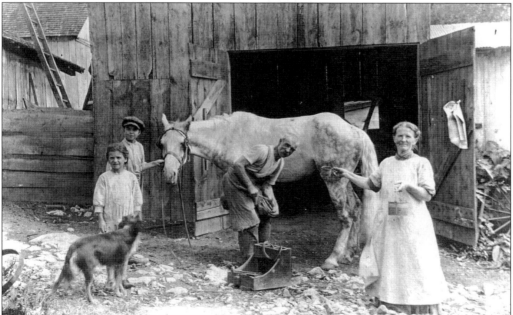

This photo shows the blacksmith shop in Leitersburg c.1910. Lewis McDowell, the blacksmith shown shoeing a horse, may have been the only smithy in town at that time. Mr. McDowell's wife holds out a drink to her husband. Their granddaughter and a neighborhood boy also posed for the camera. (Courtesy Washington County Historical Society.)

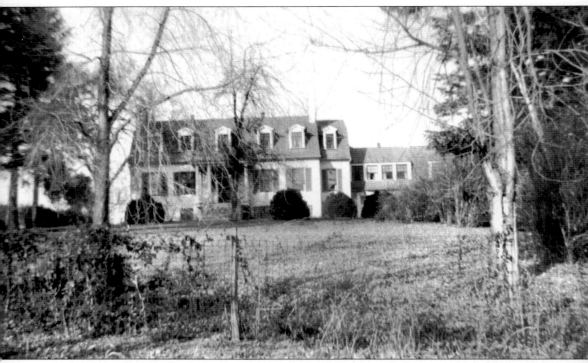

Thomas Cresap came to Maryland from England and served as a land agent for Lord Baltimore. In 1739 he received a land grant of 500 acres about two miles from Hagerstown known as Long Meadow. Cresap later moved from the area and went on to found Cresaptown in Allegany County. The colonial mansion shown here was built on the site of Cresap's blockhouse about 50 years after he left the area. Lucretia Hart, who would later marry the famous Kentucky senator Harry Clay, was born in the house. Her father, Thomas Hart, was a business partner of Nathaniel Rochester. (Courtesy Washington County Historical Society.)

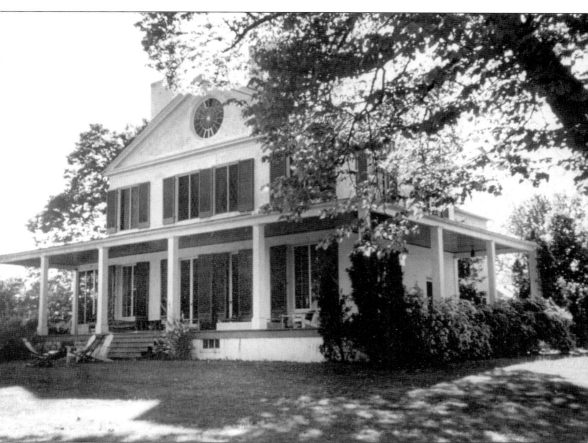

Not far from Hagerstown was a spring known to the local Native Americans as Bai Yuka, which translates into "Fountain Rock" in English. Here, near this spring, Samuel Ringgold built his elegant home also called Fountain Rock. The house was designed by architect Benjamin Latrobe (of National Capitol and White House design fame). Ringgold served as a congressman for a number of years, and other well-known political figures of the day were often among the guests at his home. The original house was purchased by the episcopal church in 1842 and St. James School was started. Today, the Bai Yuka Farms are across the road from the school and bear the same name. The above photo was taken in 1952. (Courtesy Washington County Historical Society.)

This photo shows the entrance to the source of the spring at Samuel Ringgold's home, Fountain Rock. The rear of St. James School is in the background. Henry Kyd Douglas, the youngest member of Stonewall Jackson's staff, camped near the spring on the lawn of St. James College on August 5, 1864. The small town of Ringgold in the northern section of Washington County takes its name from the original owner of Fountain Rock. (Courtesy *Maryland Cracker Barrel*.)